SEARCHING FOR THE DIXIE BARBECUE

Journeys into the Southern Psyche

Wilber W. Caldwell

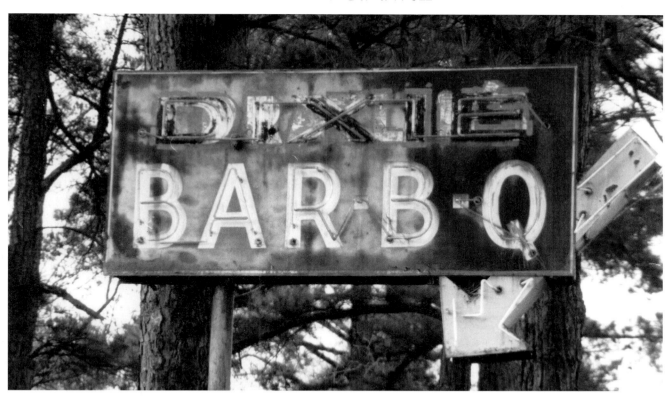

🍍 Pineapple Press, Inc. Sarasota, Florida

This book is dedicated to the ol' boys down at the Dixie Barbecue, those resolute living anachronisms, who vainly cling to so many vanishing fragments of the American experience.

Acknowledgment

I would like to thank all of the pit bosses down at the Dixie Barbecue for sharing their secrets. Varied as their methods may be, all include a common ingredient: time. Seldom found in the recipes of today's cash-register world, it is the secret to making something good.

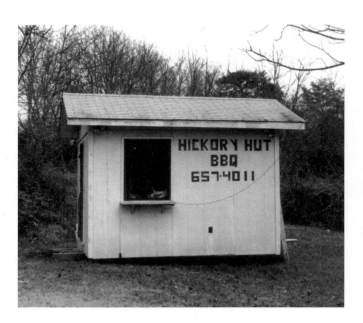

Copyright © 2005 by Wilber W. Caldwell

Inquiries should be addressed to:

Pineapple Press, Inc.
P.O. Box 3889
Sarasota, Florida 34230

www.pineapplepress.com

Caldwell, Wilber W.
 Searching for the Dixie barbecue : journeys into the southern psyche / Wilber W. Caldwell.— 1st ed.
 p. cm.
 ISBN-13: 978-1-56164-333-2 (pbk. : alk. paper)
 ISBN-10: 1-56164-333-5 (pbk. : alk. paper)
 1. Barbecue cookery. I. Title.
 TX840.B3C26 2005
 641.5'784—dc22

2005013261

First Edition
10 9 8 7 6 5 4 3 2 1

Design by Shé Heaton
Printed in Canada

Contents

Preface: Searching for the Dixie Barbecue vii

A Brief History of Barbecue: From Prometheus to Howard Thaxton 1

Charlie Doughtie and the Secret in the Sauce 16

Dora Williams, Kate Hardy, and the Mystery of the Meat 29

Pits and Cookers 38

If There Ain't No Wood, It Ain't No Good 45

Searching for Real Brunswick Stew 52

The Secrets of White Trash Cooking: Traditional Side Dishes 63

Savoring Less Than Pristine Rural Ambiences 77

The Difference between Black Barbecue and White Barbecue 95

Bragging Rights and Other Regional Exaggerations 101

Epilogue: Finding the Dixie Barbecue 107

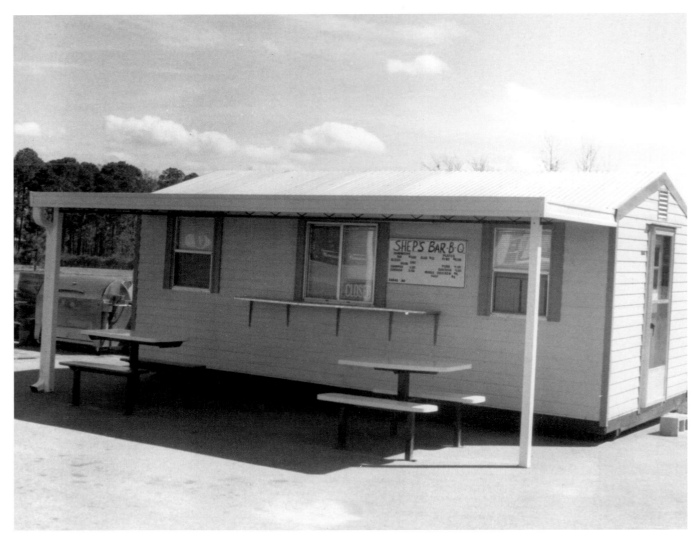

Fitzgerald, GA

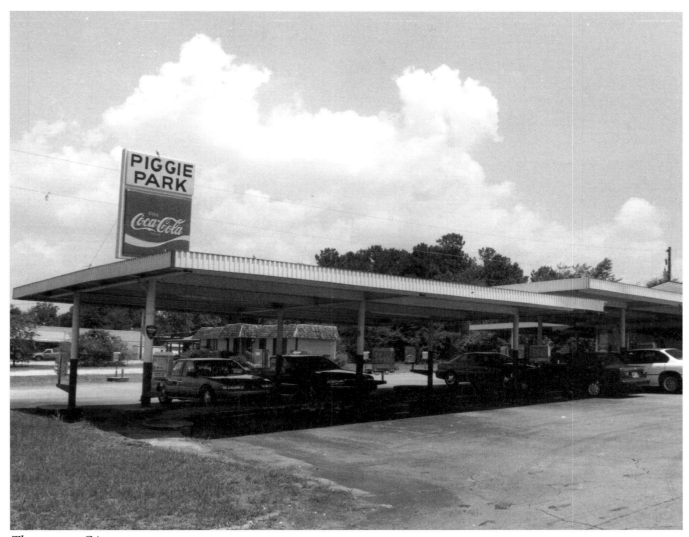

Thomaston, GA

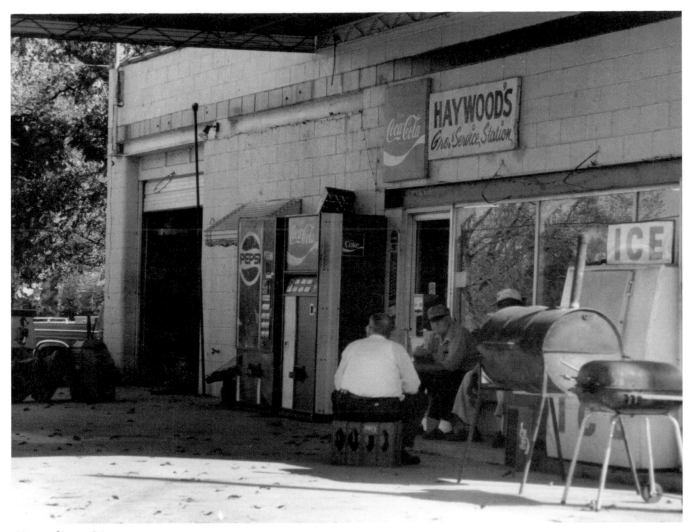

Waynesboro, GA

Searching for the Dixie Barbecue

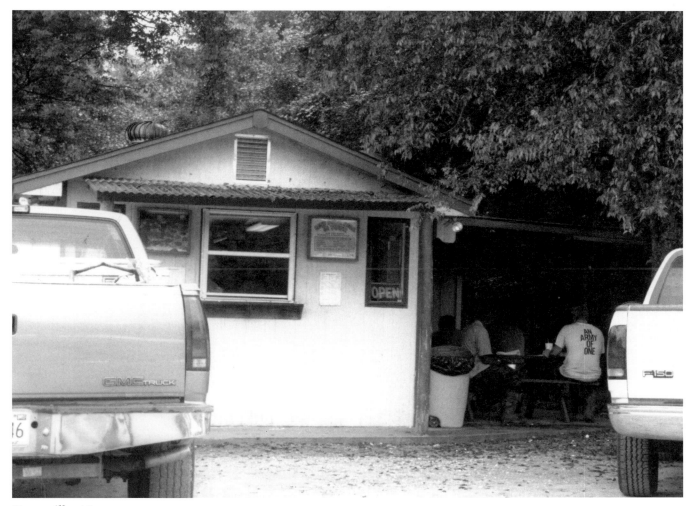

Burnsville, AL

This is both a culinary and a cultural saga. Here are glimpses of a fragment of society still tenaciously clinging to deep-rooted, primal instincts; to legends of the American frontier; and to the tarnished, hand-me-down, rural traditions of the Deep South. This is a story about (among other things) regional pride, homespun cookery, backwoods lore, self-effacing "redneck" humor, shameless braggadocio, macho self-imagery, carnivorous bravado, porcine fundamentalism, bold-faced lies, and both culinary and social intransigence. This book will supply you with the elusive answers to three questions: "What is 'real' barbecue?" "How do you find it?" and "What does it mean to be Southern?"

SEARCHING FOR THE SOUTHERN PSYCHE

At first glance, this may appear to you to be a book about food, but it is not a cookbook, nor is it a food guide. And although it offers photos and lingers at the rickety tables of scores of tiny hole-in-the-wall dives savoring good barbecue and then chewing the smoky fat with the purveyors and creators of some of the best barbecue on the planet, it is not really a restaurant guide either.

So what is it exactly? Well, you are about to discover that in the rural South barbecue is not just a food. In most of Dixie, the preparation and consumption of pork barbecue revolves around deeply ingrained mores, closely held secrets, and its own mysterious dogma. Some will even tell you that barbecue is actually a religion involving hallowed rites and ancient rituals reaching all the way back in

time and place to the twisted myth of true Southernness. You are about to explore every nook and cranny of Southern barbecue technique and lore. And along the way you will find opportunities to peer into hundreds of small, smoky windows through which you can catch glimpses into the inscrutable Southern psyche.

YOU KNOW SOMETHING'S HAPPENING, BUT YOU DON'T KNOW WHAT IT IS

Like most Americans, you probably suspect that an elusive, foreboding, "good ol' boy" subculture slowly boils away just below the surface in rural areas of the Deep South. The following pages will confirm your suspicions. Outside the great cities of the New South Sunbelt (which are really not part of the South at all), a silent undertow of cultural anachro-

Murphy, NC

Jefferson County, GA

nism still lurks out there in the black-water swamps, the green piney woods, the red clay hills, and the blue-gray mountains that lie just beyond the tree line on the interstate highway. But you never venture off the interstate, and you are thus clueless in your understanding of rural Dixie's true nature.

WHERE IS THE DIXIE BARBECUE?

Can you drive to, say, Lexington, North Carolina, or to the low country in South Carolina, or to Albany, Georgia, or to Dothan, Alabama, and then simply follow the signs? Can you draw lines on a map to direct your friends to this magical place? No, sadly, like gold, good barbecue is found only where you find it. But unlike gold, barbecue is a will-o'-the-wisp, appearing and disappearing, changing its

form from time to time and from place to place.

But what we really seek is a different kind of sustenance. We seek a cultural relic that points to an old style of "Southern-ness" that is quickly vanishing from modern American life. We seek crude essences of the frontier, unswerving backwoods mentalities, rural respect for tradition, insights into rural humor, and examples of the wild braggadocio that has created many of the tall tales that are still a part of rural American life today. In short, we seek a present-day manifestation of a myth. Real or remembered, it does not matter. The Real Dixie Barbecue is a place where the traditions of fire and hog and smoke and sauce are revered and combined in the old ways; where rustic ambiences are a treasure, not an embarrassment; where a crude code of service and an unbending orthodoxy overrides modern niceties.

You can find good barbecue anywhere these days, but when you are *Searching for the Dixie Barbecue,* you must confine your search to Dixie.

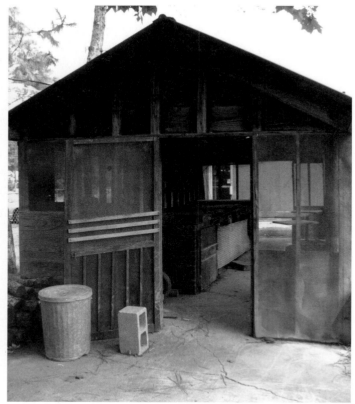

Selma, AL

AND JUST WHERE IS DIXIE?

Where are the lines on the map that define the borders of "Dixie"? There is, of course, the Mason-Dixon Line. But should "Dixie" really include Maryland or Kentucky? What about Florida, Arkansas, Louisiana, or Texas? All of these places have strong Southern traditions, to be sure. And they all make great barbecue. They all say "y'all" and "I reckon" and generally "tawk reel funny." They were all "rebels" in the American Civil War (some down here still refer to it as "The War of Northern Aggression"). But Maryland and Virginia are the inheritors of a genteel Southern tradition. Surely the Real Dixie Barbecue is a rough-edged place, and you are unlikely to find it in such sophisticated airs. Kentucky, Arkansas, and even Tennessee, although also undeniably Southern, are either "border states," or somehow "tainted" by Midwestern or Western influences. Louisiana is likewise deeply Southern in

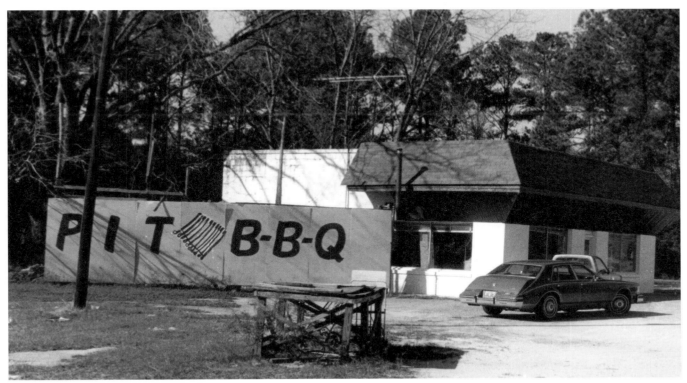

Tattnall County, GA

heritage, but she is set apart by diverse ethnic and cultural traditions that are truly cosmopolitan in nature. Lord knows, you'll find nothing cosmopolitan at the Real Dixie Barbecue. A different kind of sophistication rules out most of Florida, even though much of the northern part of that state, including the panhandle, is still as Southern as cornpone and in possession of a vibrant Southern barbecue tradition. As for Texas, well, she too is indeed Southern. But here the South meets the West, and Texans have an annoyingly categorical way of continually declaring their independence from every-

where else in the country, including the South. This part of the Texas psyche derives from a genuine American frontier spirit that lingers even today. And it would be admirable indeed, were it not, at times, so obnoxious.

So, for the purposes of this book you can give "Dixie" a very narrow definition and say that it is the "American Deep South." You can then, perhaps arbitrarily, define the "American Deep South" as the Carolinas, Georgia, Alabama, and Mississippi. This is where you begin *Searching for the Dixie Barbecue.*

ASKING DIRECTIONS TO THE DIXIE BARBECUE

If you are east of the Mississippi River and not in Florida, drive south. Once you reach the Carolinas, Georgia, Alabama, or Mississippi keep to the back roads and pass through as many small towns as possible. As you enter each town, drive slowly along Main Street until you find a group of men loitering (preferably men dressed in camouflage). Park your car. If you are from out of state, be sure that your license plates are not visible to the men. Walk up to them in a direct way and say, "How y'all doin.'" Don't try to lay on a thick accent. Just say these syllables in a kind of slurry manner, running them all together like a single word. Try not to move your lips when you speak. Don't smile or make any long direct eye contact. Do not introduce yourself, and under no circumstances should you attempt to shake hands (that would appear very foreign indeed). It is perhaps best to keep your hands thrust deep down in your trouser pockets. If you have practiced and can pass, the camouflaged men will reply by saying, "Ahiite." (This means they are "all right.") Immediately get right to the point. Ask, "Is theyah a bah-be-cue place 'round heah?" Don't push the accent too hard, and say no more or you'll blow your cover. Just listen. They will say something like this: "Yep, but it's a riide." (This means it is a long distance away.) Just nod and wait, and one will eventually break the silence and say, "Take Old State Road Number Four south out past Big Creek—about twenty miles. It's on the right. Purdy good." Thank them by saying, "Thank ya nowh." As you walk off, one of them might say, "Y'er not from 'round heah, are ya?" This is not good. It translates something like, "I do not trust you." It is best at this point to simply say, "Nope," and leave.

FOLLOWING THE DIRECTIONS TO THE DIXIE BARBECUE

After a 45-minute investigation, you will find, that "Old State Road Number Four" is now marked with new signs calling it "New Little Big Creek Road," which most locals refer to as "The Other Little Big Creek Road," when they are not calling it

Louisville, GA

"Old State Road #4." This is to distinguish it from "The Real Little Big Creek Road," which most locals refer to as just "The Bypass."

After about thirty miles you will come to the next town without having encountered any trace of a barbecue joint. Repeat the inquiries detailed above in this new town. At this point someone will probably inform you that the place you seek is not actually on "Old State Road #4," which the people in this town refer to as "Big Bethel Church Road," but off to the left down a one-lane dirt road. "Just look for the sign," they'll say. Retrace your route northward back toward the first town. When you finally find the sign, a faded red and yellow home-made affair, painted probably sometime right after World War II, you will realize that it is only visible to northbound traffic, the southbound sign having fallen down years ago. "Best Darned Barbecue Your Ever Ate," it will say. A few hundred yards down the dirt road you will find it. Closed. "Open Every Sat.," the sign will read. It is Tuesday afternoon, and no one you talked to informed you that the place would be closed. But then after all, you did not ask for the hours. You just asked where it was. And they told you.

EXPLORING THE DIXIE BARBECUE

Well, now that you have arrived, you may as well check out the place, even though it is locked up tight. It sure doesn't look like the real thing. It is shabby enough, to be sure. But it looks kind of—well—new: a new neon sign, new exterior walls,

Abbeville, GA

Lincolnton, GA

and new aluminum-trimmed windows with cheap Venetian blinds. Peeking inside you notice a brand new, low, acoustic tile ceiling, shiny new asphalt tile floor, and new plastic tables with plastic flowers arranged on each. Could this be the Dixie Barbecue?

FURTHER EXPLORATIONS

But around back you find the blackened old pit house apparently still in use, its rickety screen door swinging in the wind. On one side of the pit house is a big pile of junk including the original old rooftop sign, another faded red and yellow wooden relic. On the other side is a woodshed filled with neatly split and stacked hickory and oak. This is more like it. This could be it after all. The pit house is as old and dilapidated as ever. And the main building? Well, it's really just an old shack with a tin roof, newly encased in a cheap remodeling. All the decades of funky ambience have recently been choked out of the old building in a sterile misguided effort to move ahead with the times (and probably with the new county health codes). Still, if the food hasn't changed with the décor, this could

indeed be it. Whatever the case, you'll have to wait until Saturday to find out.

FINDING THE DIXIE BARBECUE

If you follow these directions a few hundred times, and if you are diligent and patient in your explorations, you may actually find the Dixie Barbecue. But you had better hurry. It won't be around for long. It is doomed. All across the South new generations are forsaking the old ways and moving to the city. Chances are, when the aging pit boss at the Dixie Barbecue dies, they'll have to board up the old pit house for want of a replacement with acceptable Deep South, backwoods credentials. Many charming ramshackle old joints are falling prey to modern ways. It is only a short distance from an aluminum siding remodeling to a slick new menu, including steak, a fried seafood platter, and a buffet complete with (heaven forbid) a salad bar. It does not take a New-Age manager long to realize that this new fare is easier to prepare and more profitable to serve than barbecue. After all,

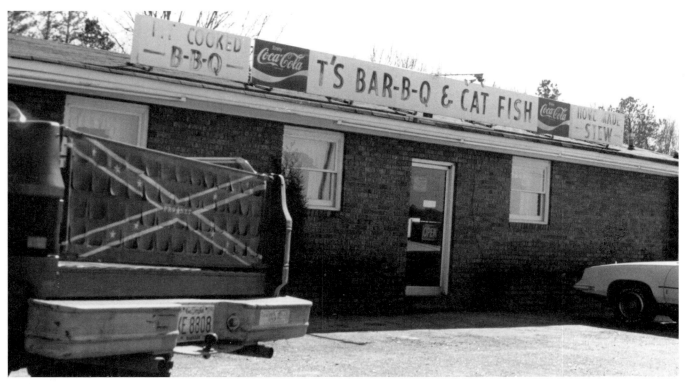

Colbert, GA

real Dixie barbecue requires love, dedication, faith, tradition, and mysterious hand-me-down intuitions born of ancient rites. Most of all, it requires time. None of these outdated elements fit today's cash register mentality.

But there is yet time. The Dixie Barbecue is still out there somewhere. Just remember what the ol' boys on Main Street told you: "It's a riide."

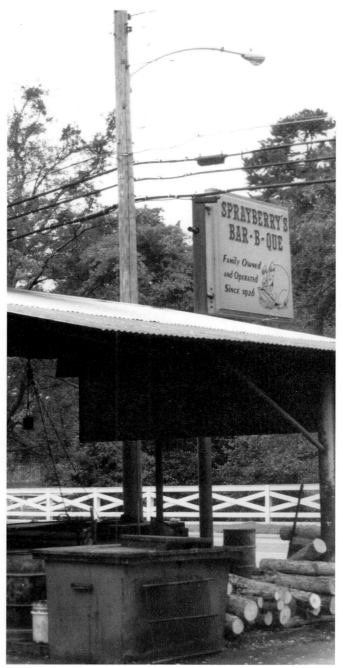

Newnan, GA

A Brief History of Barbecue

From Prometheus to Howard Thaxton

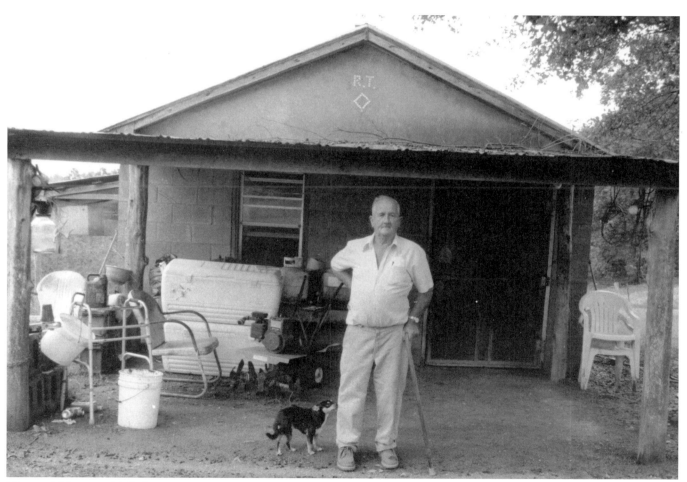

Howard Thaxton, Taliaferro County, GA

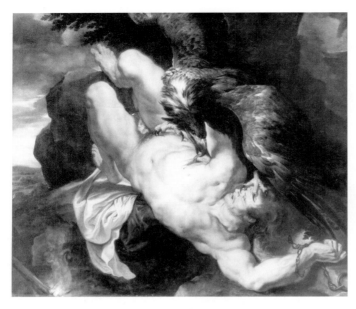

Prometheus Bound, *Peter Paul Rubens*
Philadelphia Museum of Art: Purchased
with the W.P. Wilstach Collection, 1950

PROMETHEUS UNBOUND

The story of barbecue begins long before written history. It wades up out of the swamps and thickets of prehistoric human experience, and it arrives on the high ground of recorded history as myth. Certainly you recall your Greek mythology: the Titan, Prometheus, stole fire from Olympus. He then taught men various arts (cooking probably among them). In punishment he was chained to a rock where a vulture (or some say an eagle) perpetually pecked away at his liver. It is a grim tale, but strangely prophetic. You probably also know that the Promethean legend has its counterparts in most of the world's cultures. But since this is a story about Dixie, you must follow the flow of Western tradition and stick to the Greek epic. Remember? It was Hercules who finally freed Prometheus to begin a new human era of fire and light and barbecue.

HOWARD THAXTON

From a small, dilapidated building beside his home in rural Taliaferro County, Georgia, an old man named Howard Thaxton makes and sells picked/chopped pork barbecue mixed with his special sauce ($10/qt). Howard has been doing this every Saturday and Sunday for many years. According to Howard, his father began the tradition way back in the twenties, slaughtering and then cooking his own hogs ("while they were still warm") over an open pit, then mixing the chopped meat with his own special sauce.

On any weekend you can visit Mr. Thaxton, "shoot the breeze," and pick up a sample of his work. A visit will generally begin with conversation among the clutter of old iron pots and rusting farm implements on the dirt-floor front porch of Howard's BBQ shack. This "conversation" usually

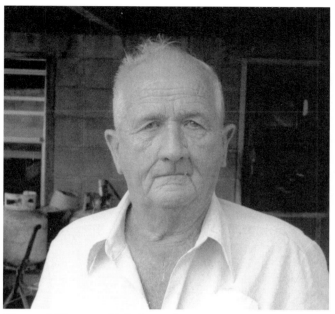

Howard Thaxton, Taliaferro County, GA

consists of little more than an uninterrupted diatribe by Howard about the depressed state of the economy in rural Greene and Taliaferro Counties and its effect on unlicensed, freelance, Saturday and Sunday only, barbecue operators in the area (of which he is the only one).

HOWARD THAXTON UNBOUND

After considerable talk, you finally get around to mentioning that you would like to purchase some barbecue.

"How much ya wont?" Howard asks.

"How about a quart?" you reply.

With this Mr. Thaxton opens the great screen door to the dark hovel that is his combination kitchen, smokehouse, and storage shed, enters the musty room, opens an ancient refrigerator, retrieves a covered bowl of chopped, cooked meat, sets it on a rusty metal table, and begins to search about the place. Finally he locates the remains of a large Tupperware bowl among the dusty junk on top of an old cabinet. He looks at it as if he has not seen it in years and mutters something even more unintelligible than the heavily accented homespun mumbling that he used to describe the county's economy. He then walks over to the cold-water sink and turns on the tap.

The Tupperware dish looks like an old dog food dish that has not been washed in years. In the bottom is a crusty film of brownish-yellow crud. The sides are stained a complementary greenish-orange. Mr. Thaxton passes this relic under the cold water,

runs his bare hand along the bottom a few times, just enough to remove the dust but not the caked-on crud. He places it on the table and begins to spoon out the meat into this newly "rejuvenated" receptacle.

You shoot a quick glance at your companions. Their jaws are agape in disbelief. As Mr. Thaxton reaches for the sauce, some of your friends leave the dark, low-ceilinged room opting for the bright sunshine outside. You remain inside as Mr. Thaxton mixes the meat and sauce together.

"What's in the sauce?" You ask.

"Well, . . ." He pauses, muses, and then smiles while recorking the ancient sauce jug. "That's a long story."

Of course it is, for you know that in addition to his long list of time-honored secret ingredients, his sauce, like the meat and the mixing bowl, contains a much longer list of even more secret, perhaps even undiscovered, microscopic "ingredients."

Before he packs the mixture into a plastic container, Howard Thaxton tests you. "Try it," he suggests.

Reluctantly you dig in with your fingers—cold meat and sauce directly from the "dog food" bowl.

God! It's good! It is *really* good!

DOWN FROM OLYMPUS

It is a "far piece" from Prometheus to Howard Thaxton. Along the way an inestimable amount of barbecue has been devoured. No one knows when Prometheus lived. So where along the way should you begin? Well, according to paleontologists, man discovered fire one day about 27,000 years ago. And according to Greg Johnson and Vince Staten in their 1988 barbecue guide entitled *Real Barbecue,* "Later that same day, along about suppertime," man discovered barbecue. OK, so all you need to do is to fill in the 27,000-year gap between the discovery of fire and Howard Thaxton's rustic, culinary artistry.

A LITTLE REDNECK HOMEWORK

How should you approach such a task? Well, first do a little reading. (Yes, rednecks can read.) Then go back to Taliaferro County, Georgia, and discuss your findings with Mr. Thaxton himself. This will help to give you the right perspective, especially since Prometheus is no longer available for comment.

You will find a number of helpful texts, beginning with *The Iliad,* which describes a great outdoor feast of "the shoulders of ewe, a fat goat, and a succulent porker," prepared and served by none other than the great Achilles himself for the entertainment and sustenance of Ulysses, Ajax, and a few other famous Greek generals and noblemen. Homer's account makes no mention of sauce, but it does refer to smoke and a low fire. Today most "experts" would agree that these are two of the three basic elements found in all "real Dixie barbecue," even though Homer never heard these words.

Of course, you will find many other descriptions of the cuisine of antiquity, including Greek and Roman accounts of smoking and grilling, medieval accounts detailing open-fire techniques, and even a depiction of a grand Norman outdoor

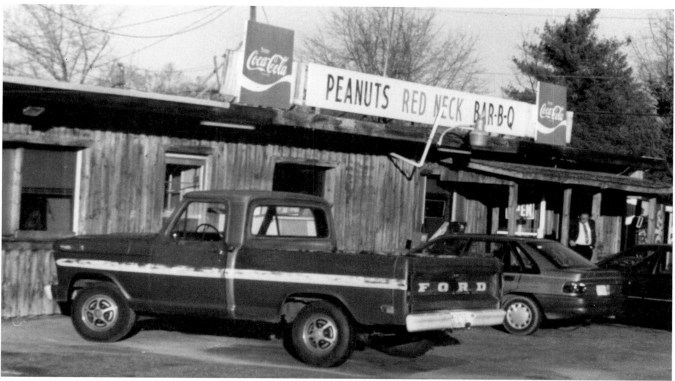

Bogart, GA

feast stitched into the Bayeux Tapestry. Embroidered images illustrate the grilling of meat and the spit-roasting of small birds over low coals. You will also find early cookbooks like the two authored by Harleian in the fifteenth century. One of these includes a recipe for spit-roasting red meat over low coals complete with a vinegar-based basting sauce. And then you will find the work of the famous French gastronome, Brillat-Savarin.

A Brief History of Barbecue

"Who?" Mr. Thaxton barks when you ask him if he has ever heard of Brillat-Savarin.

"Brillat-Savarin," you repeat, sitting in the shade of the shed-roof of Howard's barbecue shack.

"Well," he replies after a long moment of thought, "I knew some Savrin's up 'round Tignall—trash mostly—no 'count peckerwood loggers. But that was sixty years ago."

"No, Brillat-Savarin, Jean Brillat-Savarin," you press on, using your best French accent. "A Frenchman who wrote a famous book about food back in the late eighteenth and early nineteenth centuries."

"French!" Mr. Thaxton exclaims. "Lordy no!

Ain't never been no French people 'round heah."

You start to mention LaFayette or Charleston's glorious French Huguenot heritage, but you don't.

"French!" Mr. Thaxton mutters after a long silence. He slowly shakes his head, and you know his mind is spinning, engulfed in a heinous swirl of unmanly effete snootiness and unimaginable moral decay.

"Well, I only asked because Brillat-Savarin talks about the beginnings of barbecue, and I thought you might be interested," you say.

"French barbecue?" The old man asks incredulously, now obviously disturbed.

"No, no. He suggests prehistoric origins and even quotes accounts of a barbecue for the Greek generals at Troy."

"Greek barbecue?" He now looks even more troubled.

You are anxious to move on. "Well, when do *you* think barbecue began, Mr. Thaxton?"

There is a long pause. "A long time ago, I reckon."

There is another long pause. At last Mr. Thaxton, turns to look at you. He then contemplates his shoes and mumbles slowly but with conviction, "Bah-bah-cue is Amurcan."

EVERYBODY KNOWS

There it is. "Barbecue is American." No "real" Southerner would for a moment ever believe that all of the "ancient European history" in the world could possibly point to the origin of "real American barbecue." And how do all of these loyal sons of the South know that barbecue is an American invention? Because *everyone* down here knows that barbecue was invented in Dixie. That's how they know. End of story!

WORD GAMES

You don't tell Mr. Thaxton, but there is considerable support for his rigid conviction. Indeed, the word "barbecue" seems to have New World origins. When Europeans first landed in the Caribbean, they encountered the word *barabicoa* in the language of an indigenous people called the Taino. The Taino word *barabicoa* means a wooden rack supported by four stakes used for cooking meat over an open fire. In Spain, the word *barbacoa* still means some sort of grill, but it is little used nowadays. In Mexico, as in much of the Spanish-speaking Caribbean, it retains its original Taino meaning, a wooden rack for cooking meat over an open fire. But in much of the Spanish-speaking New World it has also come to mean meat cooked on an open fire. In addition, *barbacoa* is widely used in Mexico to mean meat slow-roasted in an oven dug in the earth. To add to the confusion, in some places in South America *barbacoa* has also come to mean a litter, or rough bed made from a mat of rushes fastened to four stakes, or a hut built on stilts or in a tree, or even a loft of similar design used for storing grain.

From the early Taino linguistic encounter and subsequent Spanish usages, Southerners today infer the New World birthplace of the word that they today use to describe the delicious product hiding

Estill, SC

behind so many historical smoke screens. As for earlier Old World accounts, any real Southerner's inference is that before there was the word "barbecue," there could not have been such a thing as barbecue. Or put another way, barbecue by any other name could not have really been barbecue. So if the word is American, then barbecue must be American.

MORE WORD GAMES

You will find other theories as well. The most popular is the idea that the English word "barbecue" came from the French "*de barbe à queue*," meaning "from the beard to the tail," a phrase widely used to describe the open pit roasting of whole animals. Even though *The Oxford English Dictionary* dismisses it as "an absurd conjecture," this theory is given considerable credence by early English language dictionaries like the one edited by Samuel Johnson (1746) and the American work of the famous Noah Webster (1828). Both men defined barbecue as "a whole hog or beef roasted or broiled over an open fire." Most of the stalwart defenders of modern-day "real Dixie barbecue" would suggest that the sacred Southern word "bah-bah-cue" could not possibly spring from the language of a people as snooty and morally suspect as the French. And many would further contend that Mr. Johnson and Mr. Webster (one being an Englishman and the other being—heaven forbid—a Yankee) did not know their respective literary backsides from a barbecue pit.

Still it is possible that in the early nineteenth century, Johnson and Webster's descriptions correctly defined barbecue in most English and American minds of that day. After all, the early history of this country is rich in accounts of feasts, great and small, where for most, the number of "carcasses on the fire" was the measure of the opulence of the occasion.

You don't discuss any of these word games with Mr. Thaxton, for you know he is not interested in etymology. But neither do you judge him too harshly, for you are beginning to realize that he knows many things that the rest of us do not know. The Howard Thaxtons of the world simply know what they know, and that's all that they know.

FUNDAMENTALIST DIALOGUE

But simple faith in barbecue's American birthright is not enough for Southerners. Mr. Thaxton, like most in Dixie, is equally sure of barbecue's Southern origins. Most point to North Carolina as the "birthplace of barbecue." Perhaps they are right, but if they were around today, legions of long-forgotten outdoor cooks from Achilles right on down might argue the point. It just depends on what you mean by "barbecue."

The truth of all of this speculation is that you will probably never know the truth. What else is new? The true definition and the exact history of barbecue are lost in the wood smoke of time. In the end, despite all the controversy, it really doesn't much matter. What matters is this: today in America you do have an array of mouthwatering meat dishes called "barbecue" or "barbeque" or "Bar-B-Q" or even "BBQ." And despite the fact that in most of the country no one seems to agree on exactly what barbecue is or

Talladega, AL

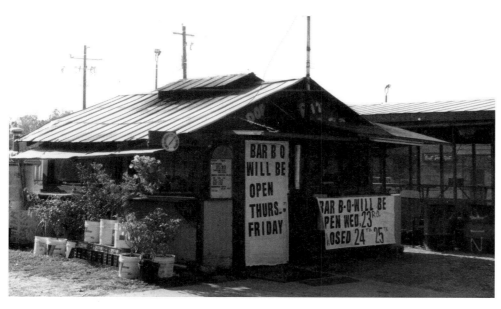

Ludowici, GA

where it came from, this is not a problem in Dixie. All across the South there is no controversy. As Howard Thaxton will gladly tell you, Southerners invented "bah-bah-cue" and the Southern way of preparing it is the only authentic way. Period! That's the problem with fundamentalism—it can make for some very short discussions.

DEFINING REAL DIXIE BARBECUE

Perhaps it all does boil down to a definition of barbecue. Since you are *Searching for the Dixie Barbecue,* you must begin in the Deep South where you'll find that most of the self-appointed elite of "real Dixie bah-bah-cue" insist on a very narrow definition. Although these definitions vary slightly from region to region, or even from town to town (not to mention from cook to cook), most Southerners agree on four fundamental elements: wood smoke, a very slow (low heat) cooking fire, pork, and the use of some kind of sauce.

YANKEE BARBECUE DEFINITIONS

Outside of the Deep South you'll find broader definitions. Mr. Webster informs you that bar·be·cue means: 1: to roast or broil on a rack over hot coals or on a revolving spit before or over a source of heat. 2: to cook in a highly seasoned vinegar sauce." Thus Webster's definition renders the coals and the fire optional and specifies that barbecuing can be done over any "source of heat" *or* that it might simply be something cooked in "a highly seasoned vinegar sauce." So by this definition both Achilles at Troy and Harliean in the fifteenth century were barbecuing even before there was such a word. What is more, by this definition, if the paleontologists are right, the first barbecue took place about

27,000 years before there was a place called North Carolina. And further, even stovetop barbecue is included. For Southerners, this kind of blasphemy is a punishable offense. Some might suggest barbecuing Mr. Webster himself over very low heat, basting him occasionally.

A RARE CASE OF SOUTHERN TOLERANCE

Despite such intransigence, you will also find that most Southern "experts" will not draw inflexible lines when it comes to the makeup of the sauce, be it a Low Country vinegar and black pepper mix-

ture, a mustardy Deep South recipe, a fiery hot Western mixture, or even some gloppy, Upcountry, tomatoey, sugary concoction. Sure, many will tell you theirs is the only proper, "real" barbecue sauce, but most would be unlikely to exclude reasonable variations from the ranks of "real Dixie bah-bah-cue." Likewise the exact cooking method would not be likely to disqualify a product from the category of "real barbecue," as long as the fire is low and the cooking time long. Whether the meat is prepared in an open or closed pit, a grill of some sort, or one of those brutish cookers designed from tractor parts

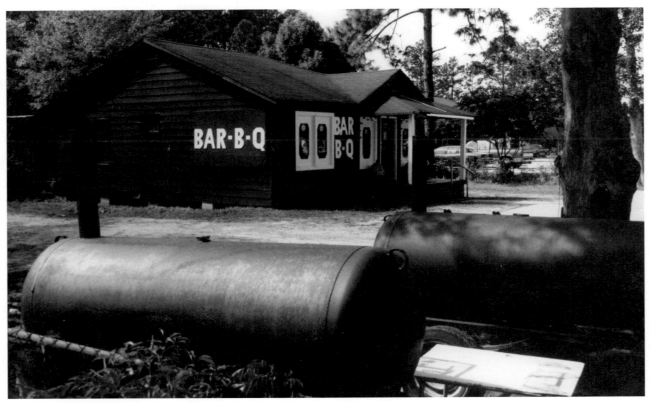

Saint Marys, GA

by an Alabama counterpart of Rube Goldberg, most "good ol' boys" would accept the result as "bah-bah-cue," although probably as an inferior variation on their own "perfect" method. Still, despite this generous condescension, a few might snicker at "sissy-sweet" sauces and at dinky "store-bought" equipment.

BARBECUE VS. GRILLING

At the bottom of it all you will find that the real question is this: what is barbecuing and what is grilling? Well, it depends on who you talk to. Interestingly, Mr. Webster defines "grilling" in a more specific way than "barbecue." "To grill," according to Webster is "to broil on a gridiron or other apparatus over or before a fire." Thus, according to Webster, "grilling" is a subset of "barbecuing." According to legions of Southern barbecue "experts," it is definitely the other way around. They will tell you that "grilling" is to cook food on a grill or grate over an open heat source. It may include broiling, roasting, smoking, drying, or baking. Don't get them wrong, these Southern backwoods gurus of "real Dixie bah-bah-cue" generally have nothing against grilling. Whatever their definition, most of them, like the rest of us, do it all the time. They just don't confuse it with "the real thing," whatever that may be.

REAL BARBECUE

When preparing to research their book, *Real Barbecue* back in the '80s, Greg Johnson and Vince Staten were sorely in need of a working definition for barbecue. Their plan was to work their way

Milledgeville, GA

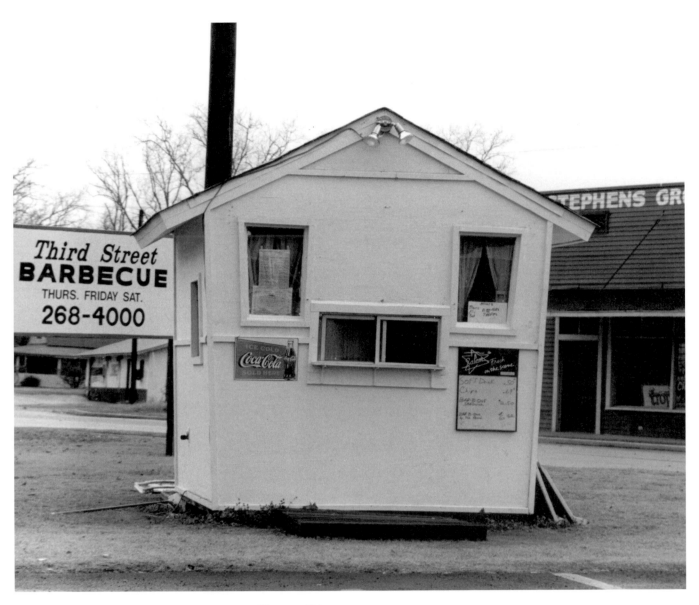

Vienna, GA

SEARCHING FOR THE DIXIE BARBECUE

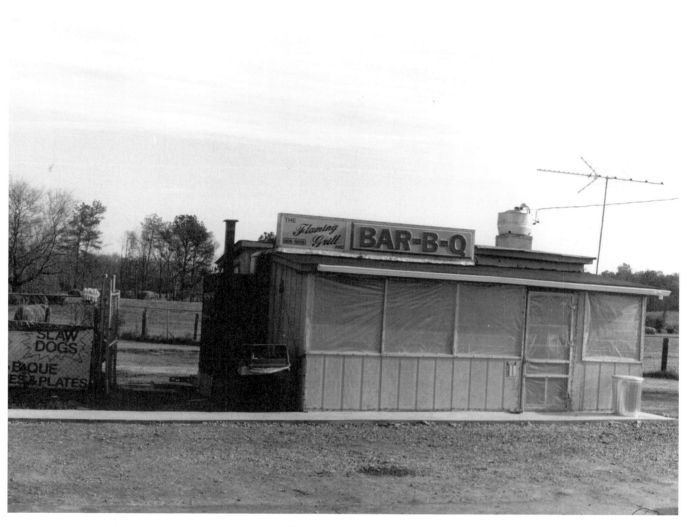

Casswell, GA

across the country rating local barbecue joints in an effort to come up with a list of the best barbecue places in America. (In the end, they claim to have eaten in 689 establishments and consumed over 200 pounds of barbecue.) Having worked through a scenario similar to the one above, they first decided to use what they called the "when in Rome" method for defining the stuff. That is to say, if the locals called it barbecue, then it was barbecue. This was the most democratic approach, but it did not take them long to abandon the scheme. According to the introduction to their book, they discarded the idea as soon as someone said to them, "In Wisconsin, they think a Sloppy Joe is barbecue." This clearly would not do.

CONCLUSIONS

So what might you conclude from all of these semantic investigations? Well, you might just say that when *Searching for the Dixie Barbecue,* you are looking for a slow wood fire. Beyond that, you might do like most Southerners do and savor the variations of sauce, types of meat (although pork is the undisputed king in Dixie), kinds of wood, and cooking techniques as you progress. To hell with Mistah Webstah. He don't know nothin' 'bout no barbecue—after all, he's just anothah Yankee. And in defense of Southern intransigence, you must remember that per capita, Southerners consume a great deal more barbecue than any other people on earth. And thus, the Southern preemptive hold on this smoky world is entirely credible at least in one sense, if not fully documented in many others. After all, where else would one search for the Dixie Barbecue—except in Dixie?

HOWARD THAXTON REVISITED

Whatever research you might conduct, you must remember this: somewhere out in the piney-woods night of rural Carolina, Georgia, Alabama, and Mississippi, dark silhouettes still huddle around hellish black-metal cookers or monolithic cinderblock pits. Elusive, smoke-shrouded figures practicing ancient rites, the Howard Thaxtons of the world are toiling away, backlit by great glowing holes in the ground. You can read all you want, but only when you locate and come to terms with these latter-day culinary Druids will you catch a true glimpse of the Real Dixie Barbecue.

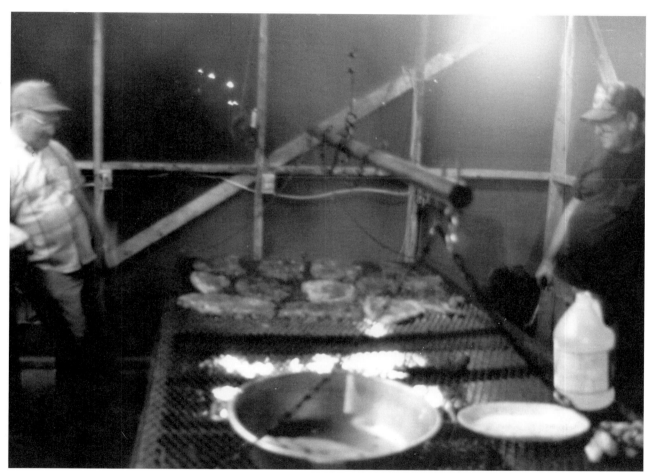

Lumber City, GA

Charlie Doughtie and the Secret in the Sauce

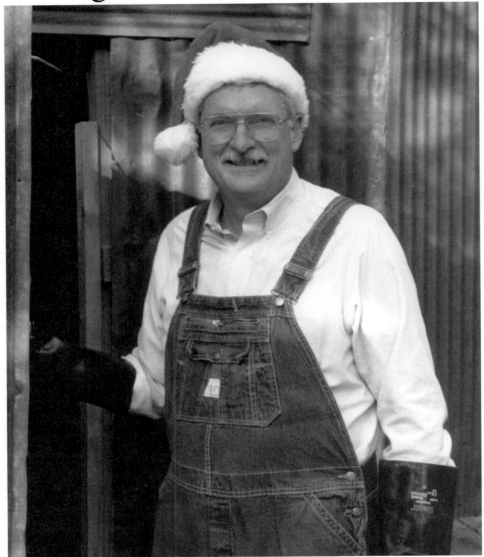

Charlie Doughtie, Spalding County, GA

On Christmas Eve crowds throng to Charlie Doughtie's rickety old farm shed in rural Spalding County, Georgia. If you are lucky enough to get an invitation, on the day before Christmas you will find Charlie's single-room pit house lit only by smoldering wood fires, strings of ancient Christmas lights, and a few crystal rays of cold December sunlight that have managed to knife their way in through seams in the rusty corrugated metal walls. The floor is dirt and gravel. A massive barbecue pit dominates the room leaving little space for the smoke-shrouded figures that gather around it.

Charlie's monolithic cooker consists of a huge brick firebox with a short masonry chimney vented by a large metal pipe. Also venting the great firebox is a vast cinderblock cooking chamber attached to one side. Heat and smoke are thus forced to envelop meat placed on high metal racks in the top of the cooking chamber, which is in turn vented by more large metal pipes twisting off at awkward angles and disappearing into holes in the flimsy tin roof of the shed. The high meat racks are accessed from above through an elaborate series of heavy, rust-covered, iron doors. The whole thing appears to be constructed from salvaged materials, the eerie remnants of some long-defunct, nineteenth-century, industrial nightmare.

You'll know Charlie Doughtie makes "the real thing" as soon as you enter the low, smoky shed. Every Christmas Eve his pit is filled with some two hundred pounds of ribs, fresh hams, turkey, sausage, venison, and God-only-knows-what-all-else. But where is the sauce? You'll soon note that Charlie does not use sauce—no sauce to marinate, no sauce to baste, and no finishing sauce to mix in, to pour over, or to dip in at the end. His recipe calls only for meat, low heat, and smoke. This technique is well respected in the Low Country of the Carolinas and Georgia, but even down in the darkest of swamps they almost always use a little vinegar and black pepper at the end to moisten and spice chopped or picked meat.

Sauceless cooking is very rare in the Upcountry, where robust sauces of many descriptions are generally employed at various stages of preparation. But Charlie Doughtie does not care. That's the way he likes it. And every Christmas Eve, a good portion of the population of Spalding and Pike County, Georgia, drop by to pay homage to his tradition. They come in the morning to have a biscuit with Charlie's famous smoked sausage (a bottle of Irish Whiskey is strategically placed by the coffee pot). They drop off their own fresh hams and turkeys and ribs and venison for Charlie to smoke, and they return in the afternoon to pick up their goods and have a beer or two. Then they enjoy a late lunch of smoked turkey, barbecued ribs, and more sausage, all unceremoniously presented without accompaniments in large, open, stainless steel pans and generally picked or pulled apart by hand by each diner right in the pan—no plates, no silver, no bread, no slaw, no napkins, no nothin'. These diners come from all walks of life, but in the end they all wipe

Brunswick County, NC

their hands on their pants and leave full and refreshed by good food and the brotherhood of their neighbors. All carry away a gift bag of Charlie's smoked sausage.

If you're lucky enough to get yourself invited, the product of Charlie Doughtie's great barbecue pit will be one of the best Christmas gifts you'll get.

Some say, "The secret is in the sauce."

THE GREAT-GRANDFATHER OF BARBECUE SAUCE

Just for a moment you might want to act like Southerners and be pigheaded. Go ahead, embrace the egotistical proposition that the early settlers of coastal North Carolina really did invent barbecue. True or not, and despite considerable evidence to the contrary, this premise will supply you with a handy jumping-off place for an exploration of the inscrutable concoction that most Southerners mis-

takenly guard as Dixie's most treasured culinary secret: "Real Southern Barbecue Sauce."

The recipe for Low Country North Carolina Barbecue Sauce is certainly no secret: about 4 cups vinegar, 2 cups water, 3 tablespoons salt, 2 tablespoons black pepper and 2 tablespoons cayenne pepper. Sure, some like a little less water to cut the vinegar. Some like less black or red pepper. Most like more. Some add a little of this or that. Whatever the variation, this, or something very much like it, is considered by most Southerners to be the great-granddaddy of contemporary American barbecue sauce. Whatever its origin, over the centuries North Carolina Low Country Barbecue Sauce has spawned the impossibly tangled family tree of "secret" concoctions that today simmer on back burners all over the rural South.

LOW COUNTRY DOGMA

You will find that in the Low Country of Carolina today the dogged simplicity of the open pit and this time-honored vinegar-based "Low Country–style" sauce still characterize regional barbecue. This sauce is sometimes used as a basting sauce during cooking, but it is more widely used as a finishing sauce to moisten, spice, and enhance the flavor of picked meat at the end. In the lowlands, it is almost never used as a marinade. Devotees of this ancient brew may not be real purists like the sauceless cooks of the Charlie Doughtie school, but like Charlie, they practice an ancient tradition. And in so doing they make some of the best barbecue on

the planet. The key to Low Country barbecue sauce, they will tell you, is that it does not so much *flavor* the cooked meat as it *enhances* the smoky flavors already in the meat. The theory goes that there is no more complex flavor than that of meat that has been slow cooked and gently smoked, and a complex flavoring sauce will only confuse, complicate, or even mask an already deliciously complex issue. Thus, flavor enhancers make the best sauces—enhancers like salt, black pepper, red pepper, and, of course, vinegar.

But as you continue your search for the Dixie Barbecue, you will also find that not everyone in the South subscribes to this limiting view.

UPCOUNTRY SAUCES

Most Southerners will tell you that Low Country barbecue sauce made its way down the coast from North Carolina into South Carolina and Georgia, where mustard was added to the brew. This was perhaps the contribution of French Huguenots in Charleston, perhaps of Creole influences from the Caribbean, or perhaps it is just what they liked. Today in the South Carolina lowlands near Charleston vinegar-mustard finishing sauces are still popular. Nowadays prepared mustard is usually used, and of course this is made primarily from mustard seed and vinegar. Thus, it is really little more than a minor variation on the original North Carolina Low Country scheme.

You will soon discover that the real change came with westward migration. On the Piedmont and up in the mountains away from the coastal plain, new sauce traditions evolved. Most involved the addition of sugar in various forms. Tomatoes were also added, but in general, most Upcountry sauces today get their tomato content from catsup, and along with tomatoes and vinegar, catsup contains large amounts of sugar. Onion and garlic were often added. These too are very high in sugar content. In addition, you'll find that most of the new-fangled backwoods sauce recipes called for either raw brown sugar or white refined sugar or both. Some added wine or beer, or later even Coca Cola, thus raising the sugar content even higher. Butter or oil and a little Worcestershire and Tabasco or other pepper sauces filled out the evolution. Most Upcountry sauces require gentle simmering. All are subtly different, but generally only with regard to spicing and proportions. Most Southern cooks don't measure or write down recipes anyway, and thus when it comes to home-brewed sauces, there is considerable variation, not only from region to region, from town to town, and from chef to chef, but also from batch to batch. Wherever you search, you will not find a science, you will find a confused art in constant flux, perpetually reinventing itself beneath a smoke screen of experimentation and inexactitude.

ROUND UP THE USUAL SUSPECTS

So you might ask, "What's so secret about all of this?" Any fool can detect the not-so-subtle pattern: vinegar, catsup, mustard, Worcestershire, sugar, oil,

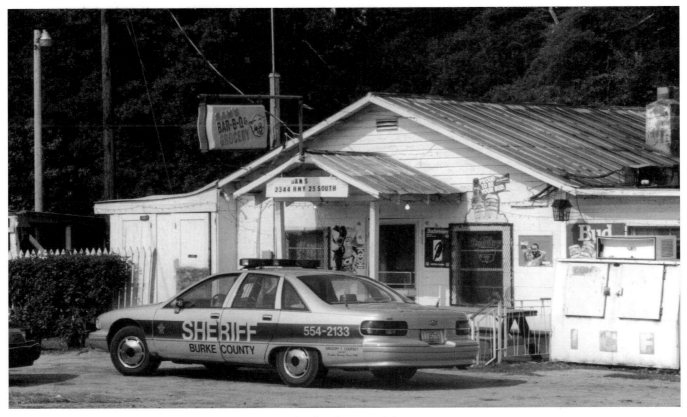

Burke County, GA

salt, pepper, and spices. Sure, everyone has their own time-honored "secret" ingredients: whiskey, beer, wine, paprika, chili powder, onion powder, garlic, thyme, bay, more whisky, allspice, cloves, pickling spice, cinnamon, chilies, soy sauce, dill, tarragon, nutmeg, still more whiskey, rosemary, sage, ginger, and on and on. But whatever the variations, the fundamentals are pretty much the same. Still, the perfection of barbecue sauce remains a tangled web, and there is no single correct answer to any of the mysteries or riddles that are simmer-ing in the sauce or in the pit. You can only conclude that barbecue sauce is a great deal more predictable than most Southerners are willing to admit. Because of this homogeny, defining distinct Upcountry regional saucing techniques is very difficult. Still, at the root of it all, most real Southerners guard their own personal barbecue sauce secret recipes with stubborn tenacity. Why? Because they are Southerners.

KEEPING SECRETS IN THE SOUTH

Of course, every Southerner will begin by telling you all of these sauce recipes are not the same. There is always a secret ingredient that makes this or that sauce special—a special secret that raises it above all others. Even though legions of honest, stalwart, well-meaning sons and daughters of the South really believe that these differences are real, they are not. As you will soon discover, most good Southern sauces are simply variations on a few well-known themes. The truth is that the secret of barbecue sauce, like all closely guarded Southern secrets, has evolved from enigmatic Southern rituals.

Consider for example, a boy's killing of his first deer. Imagine the scene: a cold fall morning, a dead doe, gutted, steaming, motionless on the ground; a fourteen-year-old boy, his rifle slung across his back, a gutting knife in his bloody hands, surrounded by a group of silent men, all armed, all in camouflage, all dipping their hands in the blood of his first kill. The great dead-black eye of the deer stares up at the boy as the men finger-paint bloody marks on his pimply adolescent forehead. The child has taken a life, and he desperately wants to give it back. He wants to cry, but he cannot. He is suddenly a man in the eyes of these peers, a primeval equal, sworn to the secrecy of a brotherhood that he does not yet understand. He will not be told any family secrets on the day of the kill, nothing about his older sister's pregnancy, none of the shabby exploits or bad advice his father and his uncles will later foolishly confide. Nonetheless, his bond is complete, and he will honor it to his death.

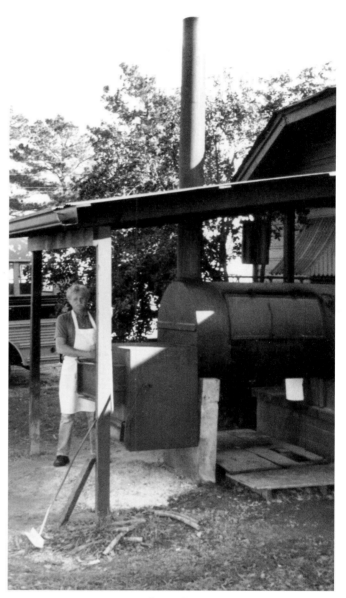

Oakwood, GA

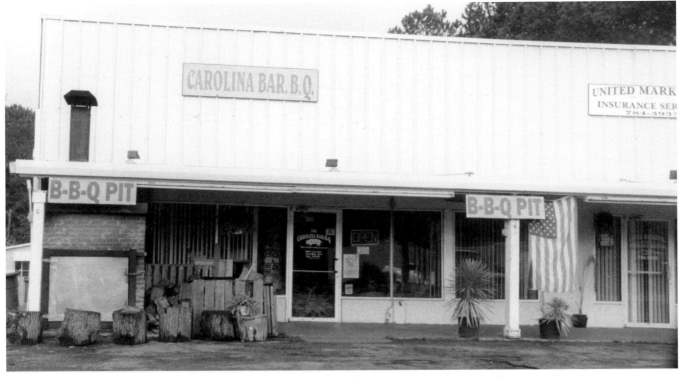

Hardeeville, SC

Later, when he receives the secret of his great-grandfather's barbecue sauce, this and other bonds will be evoked. He may joke about it all later on in life, but he will never reveal these secrets, no matter how trivial or meaningless he may ultimately find them to be.

BARBECUE SAUCE THREE WAYS

No matter how secret the barbecue sauce recipe may be, it is no secret that there are only three basic ways to employ it: as a marinade, as a basting sauce, and/or as a finishing sauce. Some pit bosses use a different sauce recipe for each of the three basic sauce applications. Many also vary each sauce recipe according the temperatures and the cooking methods to be employed, and of course according to the type of meat they are cooking. Add in the broad spectrum of regional, local, and personal sauce traditions and the permutations become large indeed. Some don't marinate. Some don't baste. And some, like Charlie Doughtie, use no sauce at all, while others put it on just about everything including slaw, potato salad, baked beans, and fried potatoes. If you get way out the country, you might be served a barbecued omelet for breakfast.

DRY RUBS

Before you leave the contentious, shadowy and covert world of homemade Southern barbecue sauce, you must briefly turn your attention to dry rubs. Technically these spicy mixtures of dry ingredients are not really sauces, but like barbecue sauces, they are often employed to infuse meat with flavor. The dry rub tradition has Old World roots and was imported to the Americas early on. Originally applied to raw meat as a preservative, nowadays rubs are sometimes used to tenderize but are more generally employed to add flavor. This can be tricky, for when exposed to heat, many rubs change the flavor and the texture of meat in unexpected ways. It is an ongoing dialogue.

With the exception of some rib lovers, Dixie barbecue fundamentalists generally turn a deaf ear to the benefits of dry rubs. Their argument against rubs would probably be compelling were they inclined to make an argument. But most of these aging rebel cooks will not voice an argument because they are stubborn, closed-mouth defenders of a sacred, self-proclaimed, "real" Southern barbecue tradition. In their minds their methods are so perfected, so time-honored, so obviously superior and, in short, so sanctified that any attempt at defense constitutes a kind of blasphemy. Like almost everything at the Dixie Barbecue it is not about dialogue, progress, enlightenment or growth, it is about blind faith.

Vienna, GA

STORE-BOUGHT SAUCES

Most commercial barbecue sauces follow Upcountry recipes: vinegar, sugar, tomato, mustard, red and black pepper, spices, and so on. You'll find scores of these products on the market and some are quite good. The familiar name-brand commercial barbecue sauces like Kraft and Hunt's are even more sugary than most homemade varieties, loading up heavily on the corn syrup and/or molasses, while the hundreds of regional "boutique" brands available in local supermarkets are often closer to restaurant or homemade mixes.

Many Southerners use store-bought concoctions as a base. They then doctor and spice it up in order to satisfy individual whims or local conventions. There are thousands of bottled sauces and all are subtly (or not so subtly) different. In the tinkering

hands of millions of self-styled "real Deep South barbecue sauce doctoring experts" (most of whom never repeat a recipe) the permutations become mind-boggling. Still, the use of store-bought sauce is rarely frowned upon in Dixie, as long as the sauce does not contain that abhorrent ingredient often called "liquid smoke," an artificial flavoring agent that sends most "real barbecue" aficionados screaming away in their pickups.

SAUCE NAMES

After a little research you discover that the naming of these commercial sauces generally follows one of several recognizable patterns. There are those that derive character from backwoods wit and homily through the use of a clever nickname or a catchy descriptive phrase, like Bubbah's Bad Ass BBQ Sauce, Bone Suckin' Hot Barbecue Sauce, Browning's Pig Out BBQ Sauce, Captain Bob's Jet Fuel, Damn Good Barbecue Sauce, Macy's Hellfire & Brimstone Hot BBQ Sauce, Mad Dog BBQ Sauce, Passover Barbecue Sauce, Roadkill BBQ Sauce, Shyster Bar-b-que Sauce (Judicial Flavors), Scorned Woman Barbecue Sauce, Barbecue Sauce from Hell, Red Mud Barbecue Sauce, Better Than Sex BBQ Sauce, Black Hole BBQ Sauce, or Wowo's Big Stick BBQ Sauce. Then there are those that rely on regional reputations employing the name of an area, a state, or a city well known for barbecue excellence like Atlanta Burning Hot Sauce or Big Daddy's Carolina Style Barbecue Sauce. Another approach involves the exploitation of the names of popular celebrities, like

the sauces marketed under the name of Paul Newman or Jack Lemon or even Jack Daniels for that matter. Better yet are sauces endorsed either by NASCAR drivers or country singers. But perhaps the most pervasive naming device is applied to the thousands of locally marketed sauces that rely on the fame of a favorite hometown barbecue restaurateur who has been bottling and locally marketing his "secret" custom sauce for decades.

NAMING YOUR OWN PERSONAL BARBECUE SAUCE

All of these naming schemes pale before the brainchild of one professional barbecue sauce bottler who offers a sort of "your-name-here" proposition. You make up a name and he will print the labels and ship you a case of custom-labeled bottles filled with his own special Louisiana barbecue sauce. This brilliant scheme forces everyone to consider what his or her own personal barbecue sauce might be called. Here are a few fanciful examples of the author's own sauce-naming speculations:

- WW's "Slap-Yer-Daddy" Georgia Style BBQ Sauce
- Piney Woods Wilber's "Let the Big Dog Eat" Georgia BBQ Sauce
- Wiregrass Wibby's "Mo-Fo" Okefenokee Black Water BBQ Sauce
- Big Wib's Authentic "So'm Bitch" South Georgia Style BBQ Sauce

Next enjoy a fantasy recipe for the author's own "super-secret" barbecue sauce.

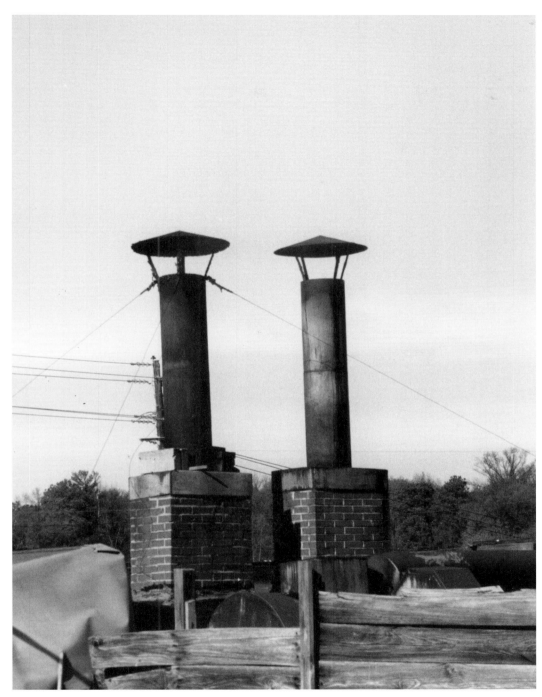

Pitt County, NC

W. W.'s "Knock Yer Dick in the Dirt" Savannah River Site BBQ Sauce

Makes about 4 gallons. Delicious for tenderizing, basting, or finishing barbecued pork ribs, pork butts, or fresh hams. This sauce may be a bit too strong for chicken and is *not* recommended for fish.

INGREDIENTS:

1 gallon Heinz Brand Catsup
1 gallon Cider Vinegar
2 quarts French's Brand Prepared Mustard
1 large jar Chainsaw Brand Cajun Style Hot Mustard
1 quart Sorghum Syrup
3 cups Brown Sugar
1 large bottle Tabasco Sauce
1 large jar Mexico Burning Brand Hot Sauce
1 cup Vegetable Oil
1 pound Yellow Onions chopped fine
1 head Garlic (about 20 cloves) chopped fine
2 Tbsp Red Devil Brand Lye (or 3 Tbsp Drano)
1/2 cup good quality White Scouring Powder
Salt and Pepper to taste
2 pounds Salted Butter
1 ounce Heavy Water (H30)* (or reactor grade nuclear waste to taste)*
1 cup Mr. Clean Brand Liquid Cleanser (or 4 ounces Ammonia diluted in 4 ounces Water)
1 quart 10W-30 Motor Oil
Clorox Brand Bleach as needed

TECHNIQUE:

Combine the catsup, mustard, vinegar, sugars, and hot sauces in a large (6–8 gallon), well-seasoned iron pot. Poke up the fire and place the pot over the coals. Bring the mixture to a simmer. Cover and simmer while you prepare the seasoning mixture.

Heat a large iron skillet to the smoke point. Add the vegetable oil. When the oil is hot, sauté the onions and garlic until soft but not browned. Lower the heat. Then add the lye and let it sizzle, stirring all the time until well blended. Sprinkle in the scouring powder to thicken and let the whole thing bubble for about 10 minutes, taking care not to brown the onion and garlic. Pour the onion/lye/scouring powder mixture into the pot containing the catsup, mustard, vinegar, etc. Return it to the simmer. Season to taste with salt and pepper. Cover and simmer. Meanwhile prepare the final enrichment.

Rinse out the skillet with a little gasoline or naphtha. Melt 2 pounds of salted butter in it.

Meanwhile dilute the heavy water in a cup of liquid Mr. Clean. When the butter is hot and the foam subsides, add the 10W-30 and the heavy water/Mr. Clean mixture to the skillet. Bring this to a sizzle, lower the heat and simmer covered for about 1/2 hour. Then uncover, raise the heat to high and boil off any excess liquid. Pour enrichment mixture in the skillet into the pot containing the catsup, mustard, vinegar, etc. Stir well. Taste and adjust for salt and pepper. Cover with a tight-fitting lead lid and continue to simmer the mixture for about a week. DO NOT BOIL! Should the sauce become too thick or too hot, add cold cups full of any good quality chlorine bleach to control the heat and obtain the desired consistency.

After a week or so, allow the fire to go out, let the mixture cool to a nice warm stage, and using an asbestos funnel, pour the sauce into glass 1-gallon jugs. Seal each jug with a lead stopper.

NOTES ON STORAGE:

This sauce cannot be frozen except at temperatures approaching zero degrees Kelvin, but if properly refrigerated, it will keep almost indefinitely. It may lose a little of its punch after about 3 1/2 years (the half-life of the heavy water) or later if you use lower grade radioactive ingredients like run-of-the-mill power plant nuclear waste. Repeating steps 3 and 4 above can reinvigorate the sauce. Of course, the usual Federal standards apply to long-term storage. It is recommended that you comply with the guidelines set down in NRC Publications: AA-4023-PGR and AA- 4023-PPX.

*NOTES ON INGREDIENT AVAILABILITY:

Heavy water is available from the United States Department of Energy, Savannah River Site, P.O. Box A, Aiken, South Carolina 29802. The U. S. Nuclear Regulatory Commission (NRC) offers useful advice regarding sources for domestic reactor nuclear waste products; these are especially plentiful in South Carolina, Nevada, and South Dakota. They are also very easy to obtain in Russia and many other former Soviet states. Weapons-grade plutonium is a fine substitute for all of the above-listed isotopes, although it is sometimes difficult to obtain. Suggested resources are currently any reputable Indian or Pakistani Restaurant Supply Vendor or selected ethnic food exporters in Yemen, North Korea, Iran, Columbia, and of course Los Angeles.

AUTHOR'S NOTE:

Although in no way plagiarism, the above folly is not entirely my own. The general idea came from my recollections of a 1970s article by *Esquire* magazine's distinguished former food editor, Mr. Gordon Leash, who upon attending a chili cook-off in Texas, published a chili recipe with a similarly outrageous approach, along with a legitimate recipe for his fantastic "Gordo's Mad Dog Chili."

THE SAUCE AT THE DIXIE BARBECUE

Despite all of this self-effacing good humor, regional branding, and manipulative advertising and positioning, it won't take you long to figure out that the crass commerciality of modern promotions is abhorrent to the regular patrons at the Real Dixie Barbecue. Down here they place little stock in marketing schemes and they don't bottle and sell their sauce. At the Dixie Barbecue, if you want extra sauce, you just ask for it, and they will give it to you for free in a Styrofoam cup, ladled directly from the five-gallon bucket simmering on an open fire out back of the smokehouse. Their only promotions are a few faded signs and a closely guarded local word of mouth. They don't advertise, and Southerners don't generally talk much to outsiders. That is why the Real Dixie Barbecue is so hard to find.

Tupelo, MS

Dora Williams, Kate Hardy, and the Mystery of the Meat

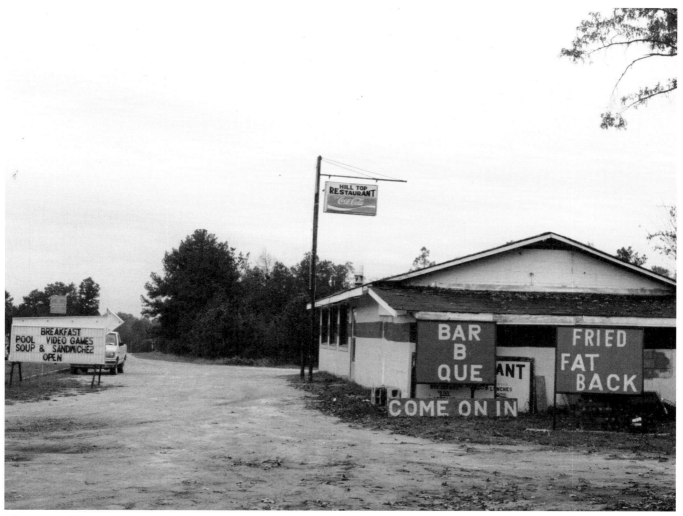

Thomson, GA

PORCINE FUNDAMENTALISM

If you ask any Dixie "bah-bah-cue expert" (outside of Texas), "What is the best meat for barbecuing?" he will immediately reply, "Pork!" with an accusing inflection and a look so incredulous that he might as well have replied, "Of course it's pork, you idiot. Are you crazy?" Still, just as controversies rage all across Dixie regarding barbecue techniques and sauce recipes, there is also widespread disagreement as to which parts of the hog are best for barbecuing. This is not to say that if you a peek into the pits of enough Deep South joints you won't find chicken or even (heaven forbid) a slab or two of beef. Occasionally you might even find game, turkey, lamb, or even goat. Still, without question, pork is king in cotton's former kingdom, and most true sons (and daughters) of the South will fight before they betray pork's exalted and ubiquitous barbecue preeminence.

THE PIGHEADED AT WAR

If you believe the traditional lore and a few very old dictionaries, back in the early colonial period on the Carolina coast the word "barbecue" first was used to describe the slow roasting of whole animals (presumably hogs) over open wood fires. The oral tradition goes on to inform you that it was in the upcountry Piedmont area of North Carolina (some claim specifically in the town of Lexington, some say Wilson) that your barbecue forefathers first dared to barbecue the butchered constituent parts of hogs. Sadly the tradition does not inform you which parts were first preferred. Was it the shoulder, fresh ham, or perhaps the ribs and loin? No one knows. And so began an ongoing war that continues today.

To be honest, it's not really a war, nor is it really even an argument. As you have already discovered, real Southerners don't argue. They generally form an opinion and then stubbornly stick to it no matter what—sometimes even in the face of compelling evidence to the contrary. Still, the battle lines have long been drawn between those who advocate the Boston Butt (the top portion of the front shoulder) and those who prefer fresh "picnic" hams (the lower front shoulder and upper front leg). Entrenched combatants punctuate this battlefield, not with noisy skirmishes, but with stubborn silence. It is the kind of blind intransigence that does great honor to a cherished Southern tradition: nobody talks; everybody knows that they are right; nobody gives an inch. Like fundamentalists everywhere, all beliefs are sacrosanct and thus not open to discussion.

All of this of course solves nothing, and the pigheaded (pun intended) defenders of each cut remain as intransigent as ever. This is one of the reasons you are *Searching for the Dixie Barbecue:* because when you find it, you might find the answer.

THE PIGHEADED MEET THE BULLHEADED

Despite their differences, Southerners will come together and stand shoulder to shoulder in defense

Ashland, AL

of pork against the proponents of barbecued beef that generally find their following in Texas. The problem that most folks in the Deep South have with Texans is that they often cop sort of a snotty attitude. Few would argue that Texans, especially East Texans, are not Southerners. They are. But they pride themselves on being Westerners too, and generally they tend to be so, well, in your face about

Texas. They bask in an abrasive aura of exclusivity, a certain regional pride that not only flaunts Texas and Texan traditions but seems to look down its nose at the rest of the South—hell, the rest of the county—OK, the rest of the world. So you'll find an ongoing standoff between the pigheaded and the bullheaded. Most Southerners will tell you that if these cowboys want to take the beef brisket—the

stringiest, toughest, most ornery part of the steer—and attempt to turn it into barbecue, then fine. Let them rave on about its merits all they want. "But it ain't as good as pork, and it won't never be as good as pork." Case closed.

RIBS

Outside the South well-meaning folks barbecue and grill a wide selection of rib cuts. Indeed, ribs probably constitute the most celebrated product of the barbecue art in America. But at the Real Dixie Barbecue "barbecued ribs" can only mean one thing: slow-cooked pork spareribs. When it comes to barbecued ribs Southerners won't have much

Bowden, GA

truck with dinky "baby back" ribs or with overly meaty so-called "country-style" ribs. But there is something about those lean "low-on-the hog" spareribs that beckons to true sons of the South. Spareribs call out to them, "Don't be stuffy, to hell with your strict Southern barbecue traditions. Go for it! Bring on the rub. Bring on the spice. Bring on the glop. I will be the better for them all." Thus it is that trying to eat real Southern barbecued ribs without getting really messy is like trying to go swimming without getting wet. You can't do it. It's an integral part of the experience.

THE FREEDOM OF CHOICE

If you understand this kind of unbending Southern intransigence, then when you find the Real Dixie Barbecue, you'll understand why there are not many choices. They always take an inflexible stand. They are never accommodating, because they are devout porcine fundamentalists. At the Real Dixie Barbecue, you can't get anything you want. You get what they want you to get, and that's all you get. In all of their squabbles, most die-hard Southern pit bosses take a hard line: "My way is the right way. Other techniques, sauces, or meats may yield passable Dixie barbecue, but none are as good and none are as authentic as mine." Period!

This is generally the rule, but like every other rule in the South it has its exceptions. Take for example a certain little roadside barbecue place in north-central Alabama. On the surface, it appears to be just another rural barbecue joint: an

Centre, AL

unadorned, totally nondescript, low, one-story, brick building beside a two-lane blacktop highway on the edge of a tiny, half-forgotten Southern town. The pot-holed parking lot degenerates into rutted gravel around back. There you'll find an open shed filled with rusty old cookers, stacks of dirty metal trays, and piles of unidentifiable junk. The place has no distinguishing features at all, save a large fading metal sign painted turquoise. This enormous neon beacon, although weathered and dying, is compelling in a camp sort of way. The building is not. Could this be the Real Dixie Barbecue?

The store-bought orange and black sign on the door says, "Closed." Yet when you push, the door swings open allowing you to enter. Inside the place is as sterile as it was outside: unadorned walls, simple tables with oilcloth covers, plastic flowers, asphalt tile flooring—all a little the worse for wear. Nonetheless everything appears clean and neat in a Spartan sort of way. The door to the kitchen is open, and you can see that the small room bustles with activity. You can see six or eight people laboring away on the stainless steel counters that line the tiny aisles between greasy black cookers, medieval stoves, and aging metal iceboxes.

As you enter, a bell sounds and presently an attractive, young, heavy-set African-American woman comes out of the kitchen and eyes you suspiciously.

"We're closed," she says.

"I'd like to talk with the cook, if he has time," you say.

"I'm the cook," the woman says without seeming to take offense, "me and Kate."

"Well, do y'all have a minute to talk about barbecue? What's your name?" you ask.

"Dora Williams," she says cautiously. With this she goes back into the kitchen and returns with a small aging white woman with distinctive facial wrinkles and long gray hair tied back in a ponytail. Dora introduces the woman as another cook, Kate Handy. You introduce yourself while Dora and Kate continue to eye you skeptically.

"OK, what do you want to know?" says Dora after a little silence.

"Well," let's start with the meat. What do you cook, pork?"

"Sure, pork," Dora replies.

"What cut, the butt?"

"Oh yes, Boston Butt."

"And you think this is the best cut to barbecue?"

"Well, some say it is."

"What do you think? Just butts, no hams?" you press.

"Oh, we do hams too," Dora replies. You glance at Kate and she nods cautiously.

"Both?" you ask incredulously. This is new.

"Well, some likes the one, others likes the other. You know, whatever you what," says Dora.

"Is it picked or pulled?" you continue, interested now.

"Sure, picked, pulled, chopped, sliced, inside, outside, whatever you like. We got ribs and sausage too."

You are beginning to feel disoriented. "But all of it is pork, right?"

"Lord, no. We got beef and chicken too. Whatever you like."

This is too much—too egalitarian—too accommodating for the Real Dixie Barbecue. And yet here is a unique and obvious solution to age-old disputes.

You are a little dizzy. Kate hands you the menu. You glance at two pages filled with choices: pork (shoulder, ham, ribs), beef (brisket, ribs), chicken (whole, half, quarters, wings), take-out barbecue (hunks of meat uncut by the pound, or picked and sauced by the quart), sandwiches, plates, or combos—all of it, here or to go, inside cut, outside cut, whole, shredded, chopped, sliced, sauced hot or mild or dry. It's mind-boggling. This can't be the Real Dixie Barbecue. Where is that closed-minded, take-a-blind-stand, frontier individualism; that brooding undercurrent of unresolved proud anger born of The Lost Cause? Where is the stubborn, mindless, fight-or-die, unreconstructed rebel attitude; the narrow-minded, Deep South, my-way-or-the-highway intransigence?

Despite the fact that Dora and Kate's barbecue is

undoubtedly excellent, something is very wrong here. They seem, well, accommodating, not to mention sane, mercantile, shrewd, and (dare you dream it) even nice. They appear strangely in tune with the times and with the microcosm of their local marketplace. The rural South that you thought you were just beginning to understand is disappearing right before your eyes. What the hell is going on here? This can't be the Real Dixie Barbecue. Remember? At the Real Dixie Barbecue, you can't get anything you want. You get what they want you to get: pork and that's all you get.

OTHER MEATS

Despite the fact that most of the Deep South's premier pit house gurus monogamously embrace pork as the only authentic Southern barbecue meat, a vast universe of meat products lies just beyond this narrow view. As Dora Woods and Kate Handy's menu reminds you, some folks enjoy barbecued chicken, sausage, turkey, or beef. Lamb and even goat are popular in some areas. Pockets of passion still exist for buffalo, venison, and other large game, and as you will soon see, many recipes for the varied but ubiquitous barbecue product generally called Brunswick Stew can include barbecued small game of all sorts, including squirrel, raccoon, opossum, game birds, and more. But at the Real Dixie Barbecue they are blind to such diversity. At the Real Dixie Barbecue you get pork and only pork. World without end. Amen.

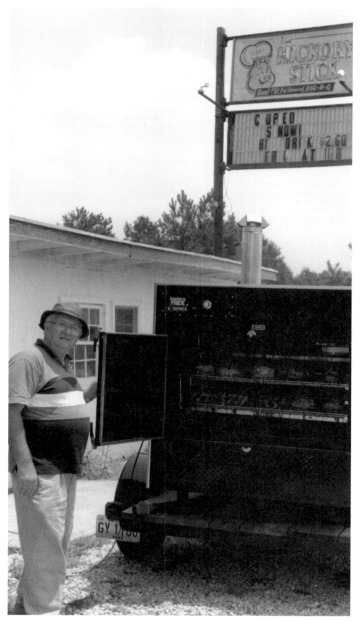

Zebulon, GA

Ila, GA

Griffin, GA

Pits and Cookers

Orville, AL

YET ANOTHER BATTLEFIELD

If you search long enough, you will eventually realize that at the most fundamental level, there are only three basic ways to cook Dixie barbecue: in an open pit, in an enclosed pit, or in some sort of "cooker." In pits the meat is slowly cooked high above a bed of coals. In a cooker there is often a separate firebox, and smoke and heat are drawn across the meat in the cooking chamber by a sort of convection achieved by various ventilation schemes. Some experts will tell you that the beauty of the pit is that as the meat cooks over the glowing coals, the fat will drip down to create a unique kind of "fat in the fire" smoking. While others will argue that since flame, heat, and smoke can be very hard to control in an open pit, enclosed pits and cookers are better because they offer precise monitoring and regulation of heat and smoke, more consistently achieving the desired texture and flavor. Still others will tell you they use both methods at once, employing specially designed pits or cookers that use both direct radiant heat from wood coals in conjunction with indirect convection style heat and smoke. At the bottom of it all it's just another Southern barbecue standoff. And like all barbecue battles, entrenched combatants have been defending deeply revetted positions for generations.

REAL PIT BARBECUE

While you are surveying this ancient battlefield you will discover that hundreds of Deep South barbecue joints, from Biloxi to the Outer Banks, announce their presence with signs that say "Pit Bar-B-Q." Could it be a coincidence that these signs don't just say "Bar-B-Q?" They distinctly say "Pit Bar-B-Q" or "Pit Cooked Bar-B-Q" or "Real Pit Bar-B-Q." Could there be a message here?

Needless to say, the open pit has been around since the discovery of fire, while the cooker is a relatively modern invention that is still evolving. Which is best? Well, it's hard to say. Many experts

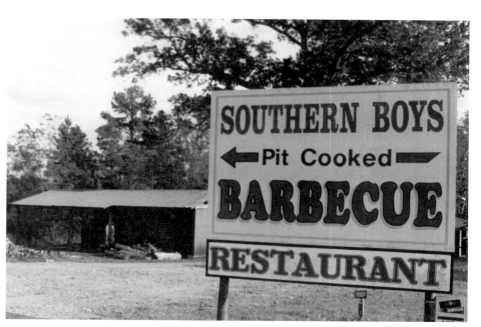

Milledgeville, GA

today get fantastic results with enclosed pits and cookers fashioned from all kinds of materials and conforming to all kinds of designs. But if you are diligent in your search, you will find that there are still hoards of inflexible purists out there somewhere way back up in the piney woods who stubbornly attempt to manipulate all the wild idiosyncrasies of the open pit in order to create delectable "real" old-fashioned pit barbecue. Open pit skills are more about feel than control, more about intuition and experience than science, and more about time, faith, and patience than about precise technique.

Broxton, GA

PIT DESIGN

One of your first discoveries will be that today most serious Southern barbecue pits are not pits at all. Most are raised metal or masonry boxes in which a bed of hot coals is maintained at or even above ground level. Some pits are open; some are enclosed. The enclosed pits not only afford more control but better efficiency. In an enclosed pit the low fire is usually accessed and stoked through small metal shovel-doors in the base. The meat is placed high up in the structure on adjustable racks. Generally there is a metal cover, either cantilevered or hinged, to allow access to the meat racks inside. Large enclosed pits often have a series of small metal overhead doors through which the pit boss can raise or lower individual racks or turn and baste specific slabs of meat. Some experts place small logs directly on the coals to stoke the fire, but

many keep a separate fire of oak and hickory and fruit woods burning on the side. From this they can shovel in coals to increase the heat or pull off coals if things get too hot. The smoke and heat in the pit can be regulated by the raising and lowering of the meat racks or by the addition and subtraction of coals and/or wet or dry wood or occasionally by the use of internal water baths acting as heat absorbers. Some pit bosses even employ a hose with a spray nozzle. But once everything is going just right in an enclosed pit or a cooker, the most important heat- and smoke-regulating techniques involve the opening and closing of labyrinthine chimneys, secret air holes, strategic ventilation doors, and countless vents.

SECRETS OF THE PIT

Each pit is different. Each has its own unique quirks: smoky spots, hot spots, and cold spots. Only the individual pit boss and his staff know all the

Auburn, AL

subtle anomalies of their own pit. If you ask any grizzled old Southern barbecue guru how he manages to maintain just the right temperature in the huge monstrosity of his homemade pit, he will probably tell you something like this, "I just know that if I can hold my bare hand on this pipe here for more than about ten seconds," he reaches up and touches one of the vent pipes in the maze of metal pipes overhead, "then things are getting too cool. If it's too hot to touch, then things are definitely too hot." In a real Southern pit, the perfect manipulation of the fire, the smoke, and the cooking of the meat can only be realized in delicate, complex, slow motion, ceremonial rites known only to the faithful.

COOKERS

You will quickly learn to use the term "cooker" rather loosely, for it is not well defined in the Southern barbecue tradition. In the usual context, it is intended to encompass the vast array of cooking devices and smokerlike units used in the preparation of barbecue in the Deep South. Some of these are fixed metal structures supported by legs or set on masonry bases. Many are mobile trailers. Some are even self-propelled. Some are factory-made and some are homemade. You might even find a huge cooker fashioned to form a credible, full-scale likeness of an old steam locomotive. The Southern barbecue cooker is as rough-edged, diverse, and quirky as those who build them and as imaginative as those who cook in them. Whether large or small; stainless steel, sheet metal, or cast

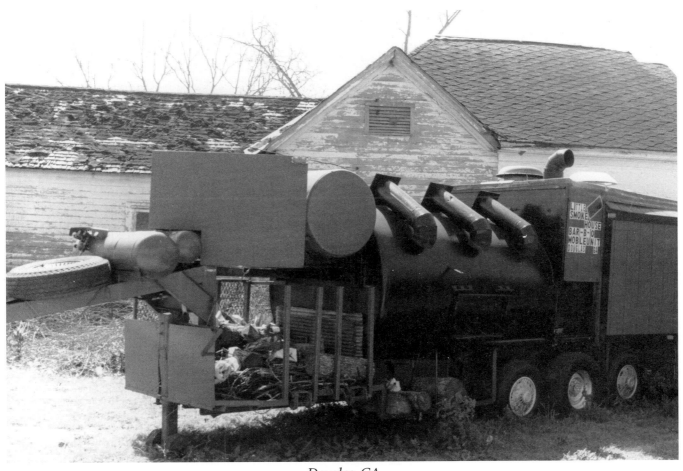

Douglas, GA

iron; mobile or fixed—the Southern cooker often represents the apex of the welder's art. The inside workings of these great black leviathans of the deep woods vary from the simple to the impossibly complex. Many incorporate exhaust covers, complex lid systems, drip pans, rotisseries, rotating racks, separate fireboxes, as well as vents, dampers, exhausts, and chimneys of every conceivable configuration.

Commercial models range in cost from thirty or forty bucks for an oil drum conversion to up to hundreds of thousand of dollars for a custom-built mobile "catering rig."

SMOKERS

Although many of the wild-looking contraptions you'll find in the piney woods are designed like

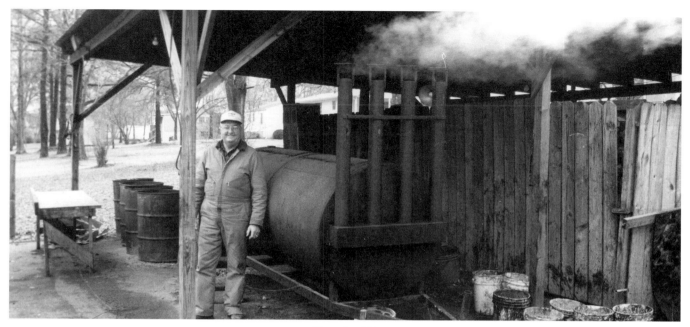

Temple, GA

smokers, in the Deep South most of the cooks you meet will not claim to "smoke" their meat. Most will insist that they are "barbecuing" their meat. Here Southerners make a subtle distinction. Smoking requires very low temperatures (maybe 90 to 120 degrees F). A good smoker allows very low-temperature smoke to be drawn into the cooking chamber via convection. Thus, "smoked" meat is not really cooked by heat at all, but rather "transformed by smoke" into a "cooked" product that resists spoilage. This can take days or even weeks. But most "smokers" are capable of achieving real Dixie "barbecuing" temperatures, which although still relatively low, are just a bit higher than smoking temperatures (generally from 180 to 220 degrees F). Working within this temperature range, they supply enough heat to slowly cook the meat (whether it be pork butts or whole hogs) in, say, eight to twenty-four hours, while gently smoking it as well. For these experts, the resulting product is not "smoked meat" at all. It is "real Dixie barbecue."

A QUESTION OF BALANCE

Like the regulation of heat, the regulation of the smoke in the barbecuing process is critical, for if things get too smoky, a strong, disagreeable, acrid flavor is imparted into the final product. This is why very few Deep South barbecue experts use a water bath in the cooking chamber. Although a water bath can be effective in regulating heat, it can

also render the process more about smoke than about heat, and this is definitely not good for real Dixie barbecue. Whether the cooker employs "smoker-type" convective smoke and heat from the side or more direct "fat in the fire" "pit-type" smoke and radiant heat from below, or a combination of both, in the end it is all a delicate question of balance.

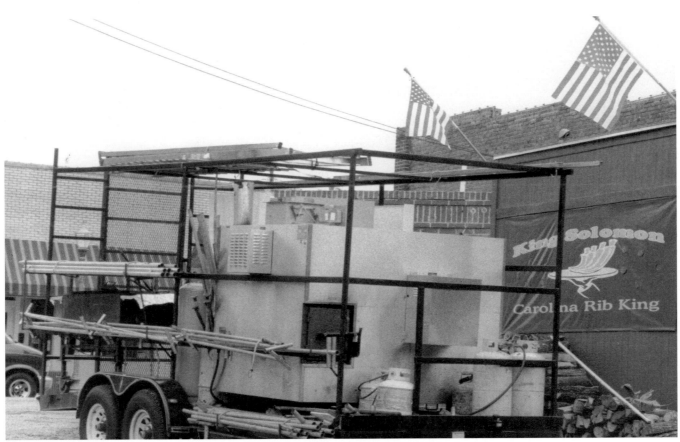

Seneca, SC

If There Ain't No Wood, It Ain't No Good

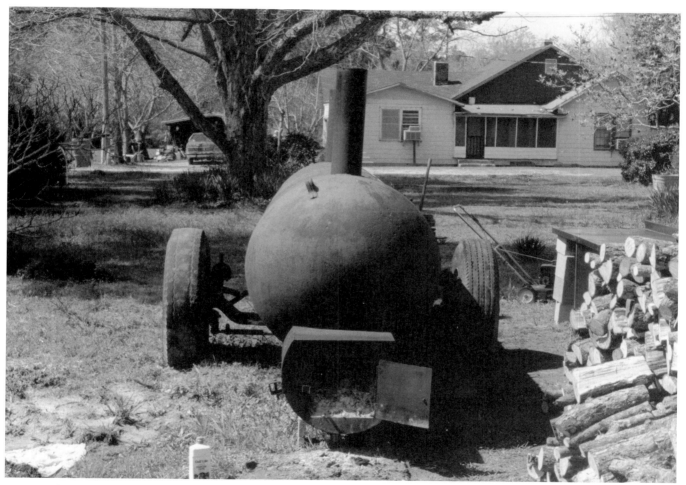

Homerville, GA

SOUTHERN MIRACLES

After all of the contention over sauces and pits and meat and technique, you are probably beginning to realize that the formation of diehard Southern opinions involves a very complex process. It generally revolves around tradition, heritage, legacy, mythology, and the like. In some rare cases there might even be a little logic or practical experience thrown into the equation just for good measure, but this kind of sanity is by no means a requirement in the Deep South. The important thing to remember is this: no matter how they are formed, Southern opinions, once fully evolved, inexplicably cease to be opinions at all; they are somehow miraculously transformed into Southern convictions. Thank you, Jesus!

In the first four chapters you discovered that there is much to be contentious about. In order to create real Dixie barbecue you must form opinions, and ultimately convictions, as to the true origin and history of barbecue. You must sort through all of the proper uses of and recipes for marinades, basting sauces, finishing sauces, and rubs. You must divine the proper types and the proper cuts of meat to be cooked. You must then perfect a cooking methodology determining how much smoke and how much heat is required, whether in an open pit, a closed pit or some kind of cooker. So with all these decisions to make and convictions to defend, you might be inclined to think that your plate is now full, overflowing as it were, with so many smoky bones of contention.

Not by a long shot. You haven't yet considered the element that fuels all of these fires: the wood.

TREES IN DIXIE

After all your traveling in the Deep South you have probably noticed by now that the place is covered with trees. On the coast and in the so-called pine barrens, you find mostly pine trees. Conifers are never used for Southern barbecue so you can forget them despite all the moonlight and romance you read about. But even in the deepest piney woods there are pockets of hardwood. And up on the Piedmont, in the foothills and in the mountains of the Blue Ridge, hardwoods forests prevail. It is hardwood that fuels the Dixie barbecue. But which type? There are so many.

HICKORY

Which type is best? Well, "Hickory," you might say. And you might be right. Indeed, many "experts" prefer hickory. But like everything else in the South, it is not that simple. First, there are many different kinds of hickory growing in Southern forests including Shagbark Hickory, Bitternut Hickory, Mockernut or Whiteheart Hickory, Pignut Hickory, and the diminutive Pale-leafed Hickory. Which is best for barbecue? You could get an argument from most experts, that is, if they were inclined to argue.

Hickory gained its considerable reputation a long time ago when it became the preferred fuel for smoking hams and bacon. Today part of the barbecuing process at the Dixie Barbecue involves smoking, but part is also about cooking and even curing,

Riverdale, GA

that is if you are using a marinade, a rub, or a basting sauce. Hickory may be best for the smoking, but is it the best wood to cook with? Some say no. And hickory, while not rare in Dixie, is nowhere near as easy to find as oak.

OAK

Oak is by far the predominant Southern hardwood. So at the Dixie Barbecue you may find hickory, but more likely, you will find mostly oak with a little hickory or other fragrant woods added in. It is a delicate mix dictated by the pit boss's preference, background, and whim, and, of course, by what is actually available.

So this isn't really so complicated, is it? Oh, yes it is! The number of oak species growing today in Southern forests is daunting indeed. There's White Oak, Post Oak, Margaretta Oak, Overcup Oak, Chestnut or Mountain Oak, Swamp Chestnut Oak, Bur or Mossy Cup Oak, Live Oak, Black Oak, Red Oak, Southern Red or Spanish Oak, Scarlet Oak, Black Jack Oak, Willow Oak, Shingle Oak, Laurel Oak, Pin Oak, Turkey Oak , Blue Oak, and Jack Oak. Each variety has its champions and detractors. Is White Oak better than Black, Red, or Scarlet Oak? What about the Chestnut Oak so abundant in the mountain areas? The dialogue would go on and on were there anyone willing to the waste the breath.

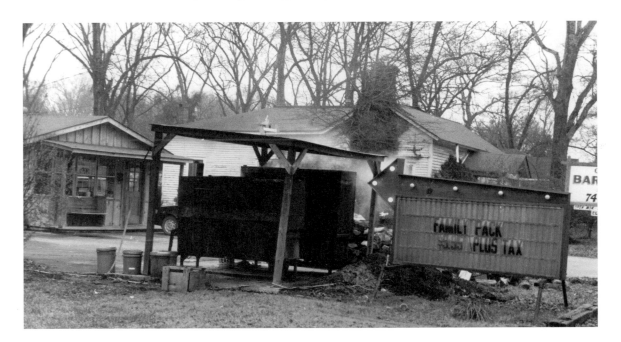

Rome, GA

OTHER SOUTHERN HARDWOODS

But it does not end here. You might remember that some gurus at the Dixie barbecue use woods other than hickory to impart certain smoky flavors. Among the favorites in this area are the many fruit-woods like cherry, apple, pear, peach, and crabapple. Also popular in this regard are nut woods like pecan and walnut (both members of the same family as hickory.) All of this is further complicated by the fact that often these exotic "smoking woods" are soaked before burning in order to create special flavors, a smokier atmosphere, and to ensure slower burning at lower temperatures. Some cooks like to do this. Others scoff at the notion.

In all of this you must also consider whole families of Birches, Beeches, Maples, Chestnuts, Elms, Ashes, Mulberries, Sweet Gums (Sycamores), and Dogwoods, all of which occasionally find their way into the pit at the Dixie barbecue. And you might even want to pay homage to the Texas favorite, Mesquite.

Every pit boss will tell you that each of these woods imparts a different flavor, burns with a different characteristic, and adds a different quality, depending on the mix and the techniques employed.

DIXIE BURNING

OK! Enough! Well, not quite. At the heart of the matter is the fire. Remember, the fire is what Dixie barbecue is all about. Now, most Southerners will agree that regardless of the type of pit or cooker and regardless of the types of wood to be used, the best results come from a carefully tended bed of hardwood coals. But there are many theories as to the best way to achieve this. Some build their fire right in the pit, starting small and then stoking as needed. Others begin with a separate open fire to burn the selected wood down to coals, and then they just shovel the coals into the pit or cooker. Some do a little of both. Some use a mix of hardwoods, and many recommend a mix of green and dry, well-seasoned wood. A few "experts" like to add soaked aromatic woods, wood chips, or even herbal branches and leaves to achieve special flavors, more smoke, slower burning, and/or lower temperatures. The variations are endless, but almost no one south of Richmond will recommend the use of store-bought charcoal. It may be fine for grilling, but not for real Dixie barbecue.

Whatever fuel is selected and whatever technique employed, every Southerner will tell you that the composition and maintenance of the cooking fire is one of the critical keys to barbecue success. Still, like everything else at the Dixie barbecue, the labyrinthine puzzles of wood, smoke, and flame are far too complex for words. Most folks just find their own secret formula and then keep their mouths shut. Why argue about it? What value can there be in dialogue when you already know you are right? It's a waste of time.

Santee, GA

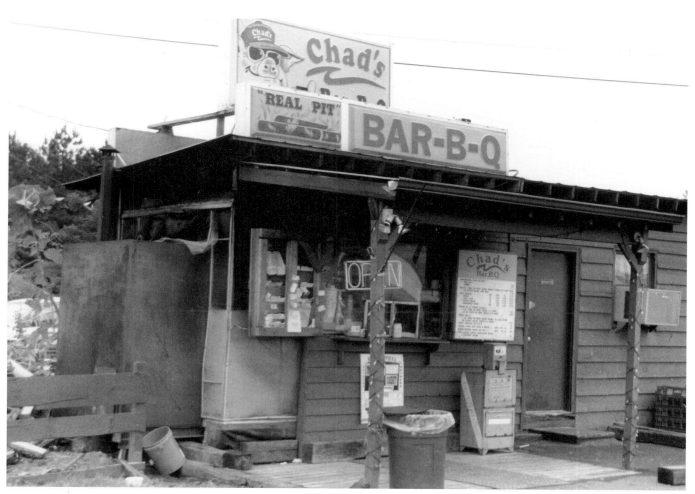

Cumming, GA

Searching for Real Brunswick Stew

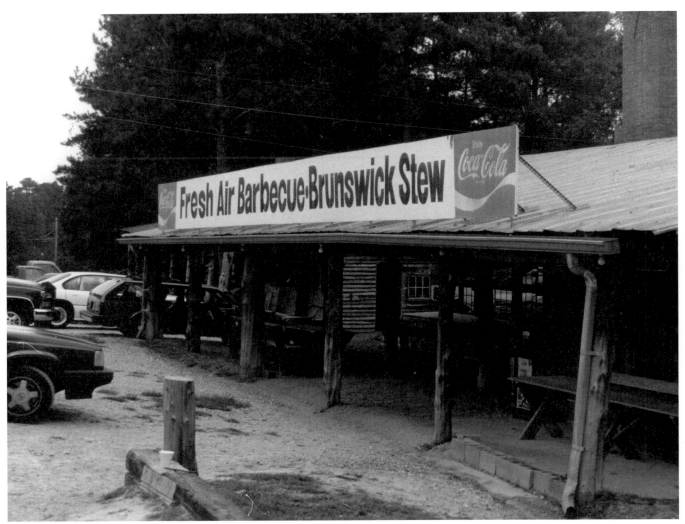

Butts County, GA

CARNIVOROUS EXCESS

In this chapter you will endeavor to find the answer to three questions. What is Brunswick stew? Where did it come from? And how did it become so inexorably linked to Southern barbecue?

When properly prepared, Brunswick stew is a delight all by itself. It is also a strangely compatible companion to a big plate of picked, pulled, or chopped barbecued pork and a runny glob of coleslaw. Despite the fact that this meaty Southern stew and tender picked pork barbecue share many common flavors, most Southerners find the redundancy quite satisfying. Remember, if you ever actually find the Real Dixie Barbecue, the ecstasy will not be about culinary balance, it will be about "bah-bah-cue," and that means it will be about carnivorous excess.

THE MANY SECRETS OF BRUNSWICK STEW

Like the many saucy essences at the Real Dixie Barbecue, you will find that the secrets of real Southern Brunswick stew remain shrouded in mystery. But the mystery is really not about how to make this delightful potion. Just about everyone down here claims to know how to make it. Nor is the mystery about where it came from. Just about everyone claims to know that too. The mystery arises out of the fact that just about everyone who claims to know the true secret of Brunswick stew disagrees about what the secret is. Indeed, it would appear that there is not just one secret, but rather thousands or even tens of thousands of secrets, at least

one for every Southerner who makes the stuff. And given the true Southerner's impossibly stubborn nature, his unbending intransigence, his almost religious reverence for tradition, his outbursts of prideful braggadocio, and his irrational resistance to change of any kind, true sons (or daughters) of the Deep South will not quickly forsake their granddaddy's secret, behind-the-barn, Brunswick stew recipe. "Now, this is *real* Brunswick stew," they will loudly declare, "not that limp-assed chick'n 'n' frozen vegetable crap you usually git."

IS THERE REALLY SUCH A THING AS "AUTHENTIC" BRUNSWICK STEW?

With so many family secrets and no foreseeable consensus, you might be tempted to ask, "Is there

Tate County, MS

really such a thing as 'authentic' Brunswick stew?" If you pose this question to scores of "experts," as you might expect, everyone unswervingly champions his or her own special recipe. But when pressed, most will eventually admit that there might be several real, "authentic" Brunswick stew recipes. Most will even eventually admit that they don't even make it exactly the same way every time. Many alter the recipe according to what they have on hand or to the season or to certain mysterious whims and inclinations known only to Southerners. Likewise when asked which recipe is best, most will again ardently pay lip service to his or her own brew. But before long most will begrudgingly yield to at least the possibility that there are others of equal merit and authenticity. In short, when pressed, few will unswervingly maintain the same hard-line tack they take when it comes to their beloved barbecue sauce recipes. For reasons that are still unknown to even the most avid barbecue and stew gurus, the world of Brunswick stew is a more forgiving place than the categorical, cutthroat world of barbecue. No matter how incongruously un-Southern it may seem, the world of stew seems to be (heaven forbid) more open-minded than the world of barbecue.

WHAT IS BRUNSWICK STEW?

Despite the fact that everyone makes their "authentic" stew a little differently, if you ask the question "What is Brunswick stew?" of many "experts" all across the Deep South, you will get surprisingly consistent answers.

Fort Valley, GA

Most will begin by trying to give a little history, saying something like, "Well, you know, long time ago folks used to use squirrel and rabbit and the like, but now they generally use store-bought chicken and a little pork meat. Nobody uses squirrel or rabbit anymore, unless you happen to have some. Here I got some quail and some dove breasts from Mr. Ivy and his boys. As for the rest, I use corn and tomato and . . ."

"No, no, man!" you might interrupt. "Think for a minute. I don't want your recipe. I want a comprehensive definition of Brunswick stew that will cover everybody's recipe. See what I mean?"

"Well, but everyone's is different," they will certainly reply.

"That's exactly the point. See? Think about it."

They do, and after they poke the fire and stir the giant iron cauldron awhile, they usually say something like this: "I reckon it's a stew made with certain meats, certain vegetables, and certain spices."

Indecisive as this definition may seem, it is excellent. It is certainly better than Mr. Webster's definition, which merely informs you that Brunswick stew is "a stew made of vegetables and usually two meats." The use of the terms "certain meats," "certain vegetables" and "certain spices" might very well render this definition more precise than Webster's, that is, if you can get a handle on what they mean by "certain."

Toward a Workable Definition of Brunswick Stew

"Certain meats?" you ask.

"Well, sure," they will reply. "Like I told you, in the old days we always used squirrel or rabbit or any kind of little birds if we had them. You know, wild game. We also made stew if we had too many old laying hens or tough old roosters 'round the yard. But nowadays I generally just use store-bought chickens, and a little pork meat if I got it."

"Never lamb or beef?"

"No, no, not lamb! Some, I hear, uses beef, but not 'round here. You can, I guess, if you have it, but I generally don't."

"What about bacon, side meat, or salt pork?"

"No, if your chickens are nice you won't need the extra fat, but many folks use bacon grease to brown the onions and all."

"And the 'certain vegetables'?" you ask.

"Well, always onion and tomato and corn. Some use lima beans or peas, and some like okra too. I don't."

"Potatoes? Beans?"

"Lord, no! Not for me, but I reckon some does."

"And the spices?"

"Most keeps that part secret, but I'll tell you some of the main ones: salt, black pepper, red pepper, sugar, vinegar, Worchester sauce, hot pepper sauce. You know, its sort of like making barbecue sauce."

There it is. At the Real Dixie Barbecue, the Brunswick stew is indeed just like a rich, soupy, overcooked version of real Southern barbecue, only with onion, tomatoes, and corn, and sometimes okra and limas. Like barbecue, the meat is slow-cooked for a very long time with salt, pepper, vinegar, sugar, and, well, what have you; you know, catsup, mustard, garlic, oregano, marjoram, sage, store-bought barbecue sauce, beer, whisky, corn syrup, Coca Cola, coffee, dishwater, Clorox, Drano, whatever.

This definition allows for almost all of the tens of thousands of Brunswick stew variations, and yet at the same time, it seems to somehow remain true to an ancient ethereal "mother concept" of the original dish, whatever that might have been. Further it suggests that Brunswick stew might share a common ancestry with real Dixie barbecue. You suspect this to be true. You just can't prove it.

SEARCHING FOR BRUNSWICK

The obvious assumption is that Brunswick stew came from Brunswick. "Sure, but which Brunswick?" you ask. Wasn't one of those little German principalities called Brunswick way back before Bismarck and German unification? And wasn't there an Austrian Duke of Brunswick and an English Earl of Brunswick lurking between those dusty, little-considered pages of your high school history books? There is also a peninsula in Chile called Brunswick and a Cape in Australia by the same name.

But those can't be right. Brunswick stew is an English, New World invention. After all, it contains all of those New World vegetables like corn and tomatoes. So what about New Brunswick, the enormous Canadian Maritime Province?

No, that can't be it. The real origins of the stew must emanate from Brunswick in the United States. But, this doesn't really help much either. There's Brunswick, Maine, and Brunswick, Indiana, and Brunswick, Missouri, and Brunswick, Nebraska, and Brunswick, Ohio, and don't forget New Brunswick, New Jersey.

That can't be it either. Brunswick stew has always been a tradition of the American South so certainly it must have originated there. Just ask any Southerner. But did it come from Brunswick, Maryland, or from Brunswick, North Carolina, or from Brunswick, Georgia? What about Brunswick County, North Carolina, or Brunswick County, Virginia?

McDonough, GA

CLOSING IN

Now you are getting closer. The fact is that both Brunswick County, Virginia, and the city of Brunswick, Georgia, claim to be the birthplace of Brunswick stew. The folks in Virginia go so far as to present you with a convenient local legend. According to Virginia folklore, the name Brunswick stew originated after a grand political rally was held for ol' Andy Jackson himself way back in 1828 at the home of one "Dr. Haskins" on the banks of the Nottoway River in Brunswick County, Virginia. Supposedly Dr. Haskins served a rich stew to his

guests from near and far, and everyone liked it so much that the stuff has been called Brunswick stew ever since.

Well, perhaps, but the folks in Georgia disagree. They present you with a much more Southern argument. Most Georgians will tell you that Brunswick stew originated early on in or near the coastal city of Brunswick, Georgia. Their arguments offer no legends, no myths, and no historical evidence of any kind. It just happened that way, and that's the way it is. Period. End of discussion.

Whether there is any truth in either of these claims, you will never know. Besides the Virginia legend does not account for the origin of the stuff, only for the naming of it. Perhaps the only truth you can safely assume is this: beginning very early on in the region now called the coastal southern United States, a distinctive regional hunter's stew evolved out of an abundance of small game, the husbandry of chickens, and the widespread cultivation of onions, corn, tomatoes, and beans. Just exactly how codified the early recipes were, you can't say. Nor can you say with any certainty how the stuff came to be called Brunswick stew. It just did.

STEW IN TRANSITION

Whatever the case may be, today you know that Brunswick stew has undergone some significant changes since its birth. Squirrels and other small game have been omitted (unless you just happen to have some), and chicken is today the principal meat used to make this mysterious potion. As you have seen, there remains considerable controversy over which other meats beyond chicken and which other vegetables beyond onions, corn, and tomatoes might be used. There is also significant disagreement from state to state, from county to county, and even from cook to cook regarding the techniques employed in cooking the mysterious stew.

THE TWO TYPES OF BRUNSWICK STEW

Even though techniques vary widely, you will quickly come to the conclusion that one can usually place most Brunswick stew recipes into two distinct categories: those in which the chicken and other meats are first boiled in the pot to create a rich broth and then boned and the picked meat added back to the broth to begin the stew; and those in which the chicken and other meats are first separately cooked by some other method, then boned and ground or chopped to become the gloppy basis for this renowned Southern meat and vegetable stew.

Now most of the recipes that you will find in cookbooks are of the first type. That is, the chicken and other meats are boiled first. This is what you might call "Virginia-style" Brunswick stew because it is the variety most common in the mid-Atlantic coastal regions, although one finds it everywhere in the South, or everywhere in the country for that matter. This is what most folks make at home. The other type, where the chicken and other meats are first separately cooked and then ground or chopped before they go into the pot, you might call "Georgia-style" Brunswick stew.

Brunswick Stew at the Dixie Barbecue

What is interesting is this. Although the "Virginia" stew most commonly appears in recipe books and is the type most often made at home, the "Georgia" variety is most commonly found in barbecue joints. It is thus the most prevalent stew recipe in the South because down here most Brunswick stew is consumed in barbecue joints. If you are lucky enough to actually find the Dixie Barbecue, it will undoubtedly be a form of "Georgia-style" Brunswick stew that you will be served. Despite its predominance in print, the "Virginia" variety might not be as representative all across the South as the roadside traditional "Georgia" variety.

All of this leads you neatly to the relationship between barbecue and Brunswick stew.

What is the Relationship Between Brunswick Stew and Barbecue?

In France almost every little town has its own butcher shop. *Boucheries,* they call them. And almost every butcher in France regularly makes his own version of a meat terrine called *paté de campagne.* This is a country-style meat paté of finely ground meats and onions and spices, baked and then weighted to press out the fat and cooled to yield a firm delicious meaty delight. It is available by the slice or by the kilogram in meat cases all over France right beside all the beautifully trimmed cuts of veal and pork and beef and lamb. All these French country patés are different. They vary according to local traditions and to each butcher's individual style and his daily personal whims.

So what does all of this have to do with barbecue? Well, when he makes his *paté de campagne,* a practical-minded French butcher is just using up all of the trimmings and scraps of meat and fat that he generates daily in the course of plying his trade. Likewise at the Dixie barbecue, when a pit boss generates enough delectable barbecued meat scraps, bones, and other smoky morsels, he makes Brunswick stew. That is why the Brunswick stew at the Real Dixie Barbecue tastes like barbecue. It is barbecue. It is ground-up barbecue meat simmered in a smoky stock that is often made from picked barbecued chicken and pork bones. Then it is seasoned with vinegar and pepper and salt and tomato and spices. You know, barbecue sauce. Add a little onion and some corn, cook it for a day or so, and "*voilà,*" as the French would say, Brunswick stew. It's a natural. That is why the "Georgia-style" of ground cooked meat Brunswick stew is what you find at the Dixie Barbecue. They are just using up the leftovers. And that is why most folks don't make the "Georgia-style" stew at home. They make the "Virginia-style" with boiled chicken because they rarely have any leftover barbecue.

Exactly how this all began is not known. And whether or not this is a true account of the complete historical relationship between Southern barbecue and Brunswick stew, can't be guaranteed. Still it makes sense. Both barbecue and Brunswick stew have been Southern traditions for centuries. It is certainly likely that most of the very early barbe-

Newborn, GA

cue "experts" were also well versed in the making of Brunswick stew. The rest is logic, although you might hesitate before using that term when speaking of the American Deep South.

WHY SOME SOUTHERNERS DON'T LIKE BRUNSWICK STEW

As surprising as it may seem, there are a few real Southerners who do not like Brunswick stew. "Blasphemy!" you might exclaim. Well perhaps. But, like all the circuitous twists and turns laid down for you in all the unwritten Bibles that ordain correct Southern conduct, there is an acceptable explanation for this.

Let's say you grew up in a small Southern town in the 1950s, and you attended public school there. It is quite possible that you do not like Brunswick stew. How can this be? For outsiders this is hard to reckon, but as it turns out, you do not like Brunswick stew today because Brunswick stew (or a very bad imitation of Brunswick stew) was a regular part of the school lunch program in Dixie for many years, beginning back in the 1940s and continuing for decades.

School lunch programs in the Deep South in the late forties and throughout the fifties constituted an insidious kind of brain-numbing torture known only to Southerners who grew up in this era and to

certain very unlucky prisoners of Asian wars. Back then from Monday to Friday, your midday life was endlessly measured out for you in five unchanging, institutional, culinary abominations of traditional Southern fare. Monday it was "barbecued chicken," a soupy stovetop mess that is difficult to describe because most have long ago managed to repress its memory. Tuesday it was macaroni and cheese. Wednesday it was "meatloaf," the amorphous, colorless, blob everyone (cooks included) referred to as "mystery meat." Thursday it was Brunswick stew. And Friday it was fried fish of a sort that to this day remains unidentified even though it has probably been scrutinized by experts who claim to know a great deal about fish and the cooking of fish.

Thousands of Southern children of the era were poisoned by this unalterable litany of maddeningly bad meals. It never changed. It lumbered on and on without variation trampling everything in its path from one end of their childhood to the other. For some it was the macaroni and cheese. As adults, many still abhor this dish. They can't get beyond the fact that it was always served on Tuesday, along with canned spinach. The resulting image of runny processed American cheese sauce swimming into the galvanized, metallic essence of barely warmed canned spinach juice turns many stomachs. Many still have nightmares. "We have ways of making you talk," the Nazi grammar school dietitian is saying to them as she menacingly approaches with her evil spoon outstretched. Dripping from it are the toxic juices of watery macaroni and cheese mingled with the noxious broth of half-warm canned spinach. They can only scream, helplessly bound as they are to their tiny cafeteria chairs.

Sadly, for others it was the Brunswick stew served on Thursdays. A watery mélange of over-cooked chicken, stewed tomatoes, lima beans, and okra, it was clumsily flavored with catsup and too much Worchester sauce. To this day, even when presented with a lovely bowl of the best, richest, smokiest, South Georgia Brunswick stew on the planet, many will turn away in disgust.

Some have even lost their taste for good barbecued chicken, having spent all of those Mondays picking over plates of greasy, bluish, pimply chicken legs warmed in a thin sauce of sugar, mustard, and catsup. Dry, sugary, overcooked cornbread was a co-conspirator at all these torturous meals. And each atrocity was dutifully overseen by hoards of those little half-pint glass bottles of milk with their wired-on paper caps. Southern children of the era can count themselves lucky if they still like cornbread, and to this day, most don't drink much milk.

A BRUNSWICK STEW EPILOGUE

If you happen to actually find the Real Dixie Barbecue, you will surely try their Brunswick stew. As you relish this meaty ambrosia, you will probably find a few small bones. Now this is not unusual. A stew made from hand-boned meat and fowl is bound to yield the occasional bony chip or morsel of cartilage. But one particular bone you find is like nothing you have ever encountered. It is shaped

kind of like a tiny stirrup no bigger than the nail of your little finger. You marvel at its hardness and perfection, but you cannot divine its origin. Now after all your barbecue adventures, you probably know your way around the skeletal anatomy of most fowl: doves, quail, grouse, turkey (both domestic and wild), and even exotic game hens and the like. This is not a bird's bone. Nor is it the bone of any domestic animal. It is much too small even for the delicate parts of the feet and vertebrae of the tiniest piglet. So what else could it be?

You think, "I hope it's a rabbit," then, "Maybe it's a squirrel. Christ, not an opossum or a 'coon, and God forbid it's a cat or a hamster or even worse." Unversed as you are in the bone structure of *rodentia* and other small animal groups, you remain clueless as to the bone's origin. You don't want to speculate further, and you don't want to ask the cook for fear that a truthful answer might challenge your appetite beyond its ability to rise to such occasions Then you remember the conversations you had with all of those Brunswick stew "experts."

Prattville, AL

"Nowadays," they all told you, "we generally use just store-bought chicken and a little pork meat. No one uses squirrel or rabbit any more, unless of course, you happen to have some."

With this in mind you finish your stew, which is delicious. Then you pay the bill and drive away thinking, "At last I have eaten real Brunswick stew, whatever the hell might have been in it today." You finally understand the secret. It's a very Southern recipe. All possible ingredients (meats, vegetables, and spices alike) are just like squirrel; no one puts any of them in Brunswick stew anymore, unless of course, you just happen to have some.

The Secrets of White Trash Cooking

Traditional Side Dishes

CURB SERVICE

SANDWICHES
CHOPPED_____2.10
SLICED_____2.50

GIANT PIG
(A LARGE SANDWICH)
CHOPPED_____3.75
SLICED_____3.95

PIG BASKET
(INCLUDES: FRIES & SLAW)
CHOPPED_____5.50
SLICED_____5.75

PLATES
(INCLUDES MEAT, STEW, SLAW,
BREAD & PICKLES)
CHOPPED_____5.75
SLICED_____6.25

RIBS
RIB PLATE (INCLUDES:
SLAW, STEW, & BREAD)____6.50
RIB SANDWICH_____3.75
SLAB RIBS_____12.50
HALF SLAB_____7.00

BRUNSWICK STEW
½ PINT_____2.00
PINT_____3.50
QUART_____7.00

SLAW ½ PINT____.95
PINT____1.75

BAKED BEANS
½ PINT____1.50
PINT____2.25

WHOLE HAMS AVAILABLE!

DRINKS
TEA_____.85
ROOT BEER_____.85
COFFEE_____.55
FOUNTAIN DRINKS: (COKE,
ORANGE, DIET COKE, SPRITE)__.85

SIDE ORDERS
FRENCH FRIES_____.96
HOT DOGS_____1.25
... ALL THE WAY_____1.75
CORN DOGS_____1.25
HAMBURGER_____2.10
POTATO CHIPS_____.60
WHOLE PICKLES_____.60
HOT PEPPERS_____.35
CUP SAUCE_____.50
BOTTLE SAUCE_____3.25
PIG PUFFS_____1.00

Riverdale, GA

THE HOLY TRINITY

OK, so when you actually find the Real Dixie Barbecue, what should you order to go with your smoky-perfect pile of well-sauced meat? On the surface, the answer is surprisingly easy. If for the moment you put aside the ubiquitous and often mysterious concoction called Brunswick stew (see Chapter 6), you are left with only three choices: coleslaw, potato salad, or baked beans (sometimes you get your choice of two). If they serve side dishes at all at the Real Dixie Barbecue, these three are what you'll find. Add an icy glass of "sweet tea" or a cold beer (if you're not in a dry county) and a plastic basket of regular ol' store-bought sliced white bread, and you have ventured as close to Nirvana as most Southerners dare to go. Sure, maybe you can also get some pickles or a bag of potato chips or a hamburger bun (as long as it is not one of those fancy sesame seed jobs). But any other choices entail patent violations of the strictest codes of Southern culinary conduct. No one knows why this is the rule. It just is. That's the way it has always been, and that's the way it always will be: coleslaw, potato salad, and beans, in the name of the Father, the Son, and the Holy Ghost. Forever and ever, Amen.

USING "GENERALLY" AND "NEVER" IN DIXIE

Easy, eh? Well, don't be too sure. That's just "on the surface." As always in the South, beneath the apparently placid, swamp-dark waters, violent torrents of contradiction swirl in chaotic disarray. Consider, for example, two very important Southern words: "never" and "generally" (pronounced "*neh*-vah" and "*gen*-reh-leh" both with a heavy accent on the first syllable.) The word "never" is used to create a hard and fast rule, like: "One *neh-vah* serves corn bread with bah-bah-cue." The word "generally" is used to create an acceptable exception for the breaking of the rule. Thus, the exact rules of Southern conduct all contain endless contingencies and codicils. So a more complete statement of the rule given above goes something like this: "One *neh-vah* serves corn bread with bah-bah-cue, except when one is serving greens with the bah-bah-cue, but one does not *gen-reh-leh* serve greens with bah-bah-cue."

DOUBLE STANDARDS

Now wait a minute. If coleslaw, potato salad, and beans are by law the only acceptable side dishes to serve with barbecue, then how did the greens get on the plate in the first place? That's the beauty of "generally." Southerners love this word, for it denotes an often sinful but usually acceptable excuse for the breaking of rules. Its logic is perverse, for the word allows for the fact that there are those who will occasionally break the rules. Some will break them out of ignorance, others out of an angry rebel mentality, but most will occasionally break rules just to experience a vicarious illusion of freedom. It is a very Southern thing, but in most circumstances all the above reasons are acceptable excuses for bending or breaking the rules. That is

Colbert, GA

why there are so many dry counties in the Deep South. It is not that Southerners don't like to drink. They do, and although one may legally drink at home in a dry county, why drink at home or in a public bar in a wet one, when you can sneak out on some secluded back road in your pickup, let the dogs run, and clandestinely polish off a pint of Jim Beam with a buddy in total and boldfaced defiance of the law? Now that's real drinking.

So you see, if in opposition to the rule, collards just happen to appear on a plate with barbecue in order to satisfy some defiant, personal, libertarian, frontier yearning, well, then it's OK to serve the cornbread as well, even though it is widely known that, "One *neh-vah* serves corn bread with ba-bah-

cue." Weird, isn't it? But true.

If all of this begins to suggest a "double-standard," then let me suggest that if you have never lived in the rural South, you don't know the meaning of the word.

TRADITIONAL VARIATIONS

Double standard or no, all of this makes perfect sense to Southerners. But it also opens the door to those who would regularly seek to defile the age-old Trinity of the Holy Three: coleslaw, potato salad, and baked beans. You'll find that today there is a growing cult that blasphemously places myriad graven side-dish false idols on daily Dixie barbecue menus right next to the revered Threesome. Some

of these imposters are the brainchildren of Yankees who don't know any better, some follow regional preferences, and some represent personal rebellious outcries. In Alabama fried catfish is extremely popular, and fried catfish is "generally" served with hush puppies. So it is not surprising (and totally forgivable) when hush puppies show up on barbecue menus from Mobile to Huntsville. Interestingly hush puppies are also a popular item on some Low Country Carolina barbecue menus. Likewise, you might find Hoppin' John (cow peas and rice) as a barbecue side dish in a few Low Country joints. This type of thing is totally acceptable. Most of the really rude irreverence shown to the ancient Southern barbecue side dish Trinity today comes from a new breed of pit bosses who kneel before the altars of more materialistic gods. Their litany is the catechism of commerce.

MODERN BLASPHEMIES

Indeed the slick, up-to-date, up-scale, even (God! No!) franchised, Dixie barbecue joint is today a fact of life in the Deep South. Many of these establishments are even run like "real" restaurants with (gasp) table service and cloth napkins and drive-thru windows and clean rest rooms and . . . golly . . . everything. Some even offer (shudder) a salad bar, and many feature a baffling array of side dishes. This is all very disturbing to the loyal patrons at the Real Dixie Barbecue, for they know that it's only a short step from there to trendy pasta salads and (heaven forbid) the effeminate ignominy of Quiche

Columbus, GA

Roberta, GA

Lorraine. Sure, it would be easy just to ignore these pagan blasphemers out of hand, but surprisingly some of these modern-day inheritors of ancient Southern pit house traditions dish up some pretty damned good barbecue. So like it or not, you must deal with them.

SOUTHERN FAVORITES

Thankfully most of the added side dish items that typify this slick new barbecue culture so far derive from old Southern favorites. You have already encountered greens, but greens are a rare offering.

Nor are you likely to find pole beans, stewed okra, or stewed tomatoes. The most usual unsanctified new additions are corn on the cob, French fries, baked potatoes, onion rings, yellow squash, or fried okra. This may be all right for some. The corn and the fries are certainly acceptable but—well—you just don't eat baked potatoes, okra, or squash with barbecue. Why? Well, any Southerner will tell you, "You just don't. That's why. You eat coleslaw! What's the matter with you people anyway?"

SURVEYING THE SOUTHERN BARBECUE SIDE DISH SCENE

With scores of side dish imposters suddenly mucking up the elegant brevity of traditional barbecue menus, many Southerners have become a bit disoriented. So you might want to try to impose a little order on the chaos created by the recent side dish invasion.

What if you were to conduct a little survey? Perhaps you could more or less randomly survey the side dish offerings of, say, fifty Southern barbecue joints, taking care to include a fair sampling of the slick new breed of barbecue restaurants, the humble roadside joints, and everything in between. While you are at it, you might also try to give fair representation to each state and to each of the regional Deep South barbecue traditions: Atlantic Tidewater, Gulf Coast and Delta, Pine Barrens, Old Cotton Belt, Upcountry Piedmont, Foothills, and the Blue Ridge Mountains. Any place should be eligible to be part of the survey except the takeaway-only roadside window operators who generally don't offer side dishes anyway. Perhaps when you compile the results of such a survey in black and white, you will be able to glean a little order in the apparent side dish chaos.

RESULTS OF THE SURVEY

The results of an *ad hoc* survey are presented in the table below. Interestingly and comfortingly, the table confirms the preeminence of the Holy Trinity. But it also confirms an undercurrent of a bizarre,

unsure, and uneven diversity created by the recent appearance of many nontraditional side dishes purveyed today by the new breed of Southern barbecue entrepreneurs. Remember, the most traditional Southern side dish of all, Brunswick stew, is not part of this study. It is fully discussed in Chapter 6.

Despite all the side dish confusion and culinary

Side Dish	# of 50
Coleslaw	48
Baked Beans	45
Potato Salad	40
Chips	30
French Fries	26
Hush Puppies	20
Corn on the Cob	12
Baked Potato	6
Squash	6
Fried Okra	6
Onion Rings	6
Fried Mushrooms	4
Yams	4
Pasta Salad	4
Rice	3
Apple Sauce	3
Greens	3
Black-eyed Peas	3

Items that appeared on less than 3 of the 50 menus are not listed.

clutter along the fast-food, four-lane bypasses that surround most of the larger towns in the Deep South, back out in the country at the Real Dixie Barbecue the side dish scene is generally still as simple and as bucolic as ever. If it's just a roadside takeout joint, maybe you can get a pint of slaw, pickles, or some extra sauce on the side or a bun or two, but that's probably about it. If there are tables set up outside beside the takeout window, or if there are counter service and tables inside, then you'll probably find only the Holy Trinity on the menu: slaw, potato salad, and beans. This is generally a paper plate and plastic fork kind of deal. If the place has table service, china plates, cloth napkins, real tableware, and all the rest, then you'll undoubtedly still find the Holy Trinity, but you may also find a few impostor side dishes thrown in as well.

WHITE TRASH COOKING

At the Real Dixie Barbecue, the preparation and presentation of the Holy Trinity is almost always extremely humble. It usually reflects what some like to call "white trash" cooking. So what do they mean by white trash cooking? Well, it is not real Southern down-home county-style cooking, nor is it soul food, although it is a close relative of both. White trash cooking is a relatively new cuisine that derives from the simplicity made possible by the modern-day availability of prepared foods. Especially important here are canned foods, prepared condiments, and store-bought sliced white bread. The style is generally characterized by a certain laziness

Millbrook, AL

that manifests itself in a series of shortcuts for the cook. Sure, in the broadest sense white trash cooking can include scores of real Southern favorites like greens with fatback or black-eyed peas with onions and smoked ham hock and so on. But it also features such delicacies as that ubiquitous tuna-noodle casserole made with canned tuna and Campbell's cream of chicken soup, topped with crushed-up potato chips, or the equally omnipresent canned French-cut green bean casserole, with canned cream of mushroom soup, topped with those greasy little canned fried onions. There is also the ever-popular macaroni and cheese casserole made with Velveeta cheese. Marshmallows and Jell-O comprise the principal dessert ingredients in white trash cooking. Snack items include the cold collard sandwich (cold collards squeezed dry, dashed with hot sauce and presented with lots of mayo between two pieces of white bread), or the "Kiss Me Not" sandwich (yellow prepared mustard and sliced raw onion on white bread). This list goes on and on, but you get the picture.

Milner, GA

You should note here that the term "white trash" in this context does not necessarily imply the low morality, meanness, or shiftlessness so often associated with the term. Here it only means rural, Southern, white, uneducated, poor folks. White trash cooking is familiar to all Southerners, rich and poor alike, because it was the mainstay of school lunches in the Deep South for decades. Veterans will also recall eating a lot of it during their service years.

White Trash Cooking at the Dixie Barbecue

Now all of this may sound tongue-in-cheek, condescending or even cynical to you. Well, it might be if you are only talking about white trash cooking, for to put it as kindly as possible, white trash cooking is not really very exciting. But there is no cynicism possible when you talk about the white trash slaw, potato salad, and beans served up at the Dixie Barbecue. In the South this is what one eats with barbecue. This is because when Southerners want bah-bah-cue, they want *bah-bah-cue*. And so authentic Deep South barbecue side dishes are generally designed *not* to distract from the main event. White trash recipes are thus perfect. They are not really bad, but they are not very good either, and that's the way they like it at the Real Dixie Barbecue.

Side Dish Logic?

Such logic could only make sense to a Southerner. But think about it. If Southerners want great Southern-style vegetables, well then, they just go home. Or they'll just go down to that little mom-and-pop lunch restaurant on the square or out on the highway and order a "Meat-and-Three," which is the Southern term for what Yankees often call a "Blue Plate Special." There they get a choice of several meats (chicken, ham, meat loaf, pork chops, country-fried steak, and the like) and a choice of three vegetables from a very long list of Southern-style delights, all served with big hunks of cornbread. Or if they really want vegetables, they can get the vegetable plate, a choice of four vegetables with cornbread and no meat, and they'll save about a buck and half. This is a well-balanced meal.

Back at the Dixie Barbecue, the meal is not about balance. It is about focus, and the focus is on barbecue. For real Southern barbecue lovers, side dishes are unimportant, even superfluous. Thus, the preferred white trash recipes employed at the Real Dixie Barbecue intentionally render the slaw, potato salad, and beans nearly invisible because this is exactly what is desired. *Ipso facto!*

With all of this exposition under your belt, now take a close look at each member of the Holy Trinity, white trash style, which is to say the way you'll find it at the Real Dixie Barbecue—if you are lucky enough to find it at all.

Cole Slaw

The recipe for coleslaw at the Real Dixie Barbecue constitutes coleslaw's simplest white trash incarnation. Here you will find no caraway seeds, no Dijon

mustard, no raisins, nuts, or fruit, no fancy bottled dressings, no sour cream, no bacon or shaved ham, and no French herbs. You'll just find salted shredded or chopped cabbage in a simple store-bought mayonnaise or vegetable oil dressing, and little more.

In the Low County, the cabbage is sometimes sliced or shredded very thin in a processor or by hand instead of chopped. It is then dressed with a little oil, vinegar, salt and black pepper (that is to say, Low Country barbecue sauce). A little grated or sliced onion is then added and sometimes a very small amount of mayonnaise, maybe some yellow mustard and sometimes a little milk or buttermilk. Don't ask me why the sweet milk does not curdle in the vinegar, but it does not. At Low Country barbecue joints, slaw is generally served in a separate bowl.

In the Upcountry, the cabbage is almost always chopped, often very finely using a food processor. Then a large amount of store-bought mayonnaise (or one of those commercial-brand, sweet, mayonnaiselike dressings or spreads) is added along with some sugar, salt, pepper, a dash of vinegar, chopped onion, maybe some celery seed or some finely chopped sour pickles or sweet pickle relish, and occasionally grated carrots and/or shredded green bell pepper for color. It should here be noted that modern, shortcut, prepared seasonings like garlic, celery, or onion salts and powders often find their way into many white trash recipes, including coleslaw.

This firm but runny Upcountry coleslaw mélange is sometimes served in a separate bowl, but it is most often dished up right next to the meat and other side dishes. This allows a thin, white, sweetish liquid to escape and freely mingle with everything else on the plate. In the South this kind of soupy interaction is not necessarily considered undesirable, especially if there is sliced white bread on the table. The most elegant white trash presentation of finely chopped coleslaw is the perfect semi-spherical coleslaw mound. This sublime effect is usually achieved with the aid of an ice cream scoop.

In the central North Carolina Piedmont you will often find what locals there call "red coleslaw" on the plate next to your chopped pork barbecue. This tangy variation replaces the usual mayonnaise-based slaw dressing with a catsup-and-vinegar-based dressing. In fact it is not unusual for Upcountry slaw all over Dixie to be spiked with a big splash of barbecue finishing sauce. Whether a sweet/sour, tomato-based, spicy mix, either right from the store-bought jar or from some dusty bottle of secret brew, this spicy addition turns the coleslaw sauce either red or a rich brown color and creates what most Southerners call "barbecued coleslaw." Surely food experts and gourmets all over the planet will here rise to strongly object, pointing out that using the same sauce on the meat and on the side dish is contrary to the most basic and universal of culinary rules. They will most certainly suggest that this "barbecue on barbecue" presentation robs the meal of balance, depriving the coleslaw of its characteristic

and cherished identity as a crispy, tart counterpoint to the soft sweetness of the spicy meat. Southerners will scoff at this suggestion. Everyone down here knows that if a little barbecue sauce is good, then a whole lot is even better. If the coleslaw at the Dixie barbecue is not of the "barbecued" variety, but rather a perfectly tart-sweet accompaniment for the smoky meat, then many Southerners will order a little extra sauce on the side and mix it into their slaw. I mean why eat "plain ol' whimp'eh coleslaw with yo' bah-bah-cue when you can eat spicy, robust, 'bah-bah-cued' slaw"? It's a "no-brainah," son!

POTATO SALAD

Like the simple white trash recipes for coleslaw, you'll find that the white trash recipes for potato salad employed at the Real Dixie Barbecue are also generally of a bland, straightforward variety. Ingredients usually list only boiled potatoes, large amounts of mayo, a little diced onion, maybe a dab of mustard, sometimes a few boiled eggs, perhaps some pickle relish or finely chopped sour pickles or just a little of the pickle juice from the jar, sugar, salt, and pepper. You'll find no pimentos, no bacon or ham, no fancy seasonings like lemon pepper, celery salt, or caraway seeds, no fresh herbs or herb-flavored vinegars, no ripe olives, no sour cream, not even chopped celery (one does not want a "crunchy" Yankee-style potato salad). In this regard the potatoes used in white trash recipes are always russet potatoes or other types of very starchy baking potatoes, and they are generally cooked until

they are quite soft. They are then "mushed" up thoroughly in the mayonnaise, almost to the consistency of lumpy mashed potatoes, but not quite. The use of firmer red or white potatoes is rare at the Dixie Barbecue. With this vigorous mashing, a highly viscous (but still just slightly runny) final product is thus rendered as devoid of texture as it is of flavor. Like white trash coleslaw, this unimaginative goo lends itself well to the perceived elegance of "ice cream scoop, semi-spherical mound" presentations. Also like white trash slaw, white trash potato

Douglas, GA

salad is often infused with generous helpings of barbecue sauce (either the store-bought variety right from the jar or one's special "secret" sauce) to create "barbecued potato salad." The addition of the sauce overpowers any subtlety that may have accidentally been achieved in the salad, while it also bestows a most unappetizing color on the entire dish. But remember, you came to eat barbecue. You are not here to mess around with "regular ol'" potato salad when you can eat the "barbecued" variety. Some white trash cooks employ a more subtle technique to create a barbecue flavor in their potato salad. This is achieved by adding a cup or so of barbecue sauce to the potato boiling water.

BAKED BEANS

You'll find that white trash baked beans at the Dixie Barbecue are usually not baked at all. They are generally dumped right from supermarket or institutional-sized cans into a large stovetop pot where they are combined with other white trash ingredients like catsup, molasses or corn syrup, salt, brown sugar, and often barbecue sauce (again either the store-bought variety or a private brew.) This soupy mess is then cooked down a little on top of the stove to combine the flavors and to create the desired thick, but still runny signature texture of the beans at the Dixie Barbecue.

HOW TO EAT DIXIE BARBECUE

Now that you have your barbecued pork all sauced up, surrounded by the obligatory trilogy of side dishes, you might think you are ready to eat. But do

Warwick, GA

you know how?

Like almost everything else in the rural South, an understanding of the proper etiquette for eating barbecue involves almost inborn insight into a complex regional double standard. There are actually two sets of rules regarding acceptable table manners for the eating of barbecue. The trick is to know when to use "regular ol' table manners" and when to use "barbecue table manners." Rural Southerners know instinctively. There are several useful guidelines for non-Southerners.

First, if there is table service (as opposed to counter service), or if cloth napkins (as opposed to paper napkins) are supplied, then "regular ol' table

manners" are probably in order. This rule holds except in cases where paper plates are employed, and then "barbecue manners" are usually appropriate. In the case of a buffet, the paper plate rule holds, but the paper napkin rule might not, especially if other niceties are present. Always use "regular ol' table manners" if there is a salad present. Generally the presence of "fancy" side dishes beyond slaw, potato salad, baked beans, hush puppies, or fries will suggest "regular ol' table manners," unless, of course, paper plates are used. All this can be quite tricky, and there are other factors involved, many quite subtle. So when in doubt, just stay cool and watch other people. You will quickly learn to spot "barbecue table manners."

So what are these different codes of table manners? You know what "regular ol' table manners" are. They are the ones you learned from your mother. You know, put your napkin in your lap; put a wad of butter on your butter plate first, and then butter your bread from that, not from the butter dish; don't hold your knife in a fist like a dagger; never let a used utensil touch the table cloth; don't put the entire soup spoon in your mouth, sip from it, but don't slurp; sit up straight; chew with your mouth closed; don't pick your teeth; and so on. You can be pretty sure that if you are in a place where you must use these tedious conventions, then you are not at the Real Dixie Barbecue; and you can be absolutely sure that if you are supplied with either a bread and butter plate or a soup spoon, then the barbecue won't be any good at all, so it's probably best to order something else or leave and go someplace else.

So what are "barbecue table manners"? Well, they are not an open license to do anything you please. Many of the niceties of "regular ol' manners" are included, but they are generally a great deal freer than "regular ol' manners." In general, with "barbecue manners" the emphasis is on function, not style. The hands are used in tandem with eating utensils. You may eat French fries or hush puppies with your fingers, even if you dip them in catsup or sauce, but you generally don't eat barbecue with your fingers, unless its ribs or barbecued chicken pieces. You use a fork if the barbecue is chopped or picked, and a knife and a fork if it is sliced, but it is customary to kinda push any stray pieces onto the fork with your fingertip or your knuckle, and then wipe your finger on a paper napkin. In this regard, you might employ many napkins at once; one in your lap and a couple on the table to wipe your hands on. A good barbecue place will supply each diner, not with a single napkin, but with a whole stack of napkins or paper towels. Eating barbecue, and especially ribs, is a messy business, and it is not at all unusual to see diners with a pile of wadded up used paper napkins beside their empty plates after a meal.

If there is bread on the table, especially sliced white bread, then a technique called "sopping" is widely accepted. In "sopping," a piece of bread is used to push food onto the fork, and when the bread becomes soaked with barbecue sauce or coleslaw juice, it is eaten by hand. If there is leftover sauce on the plate, it may also be "sopped" with

bread at the end of or during the meal. Brunswick stew may also be similarly "sopped."

With "barbecue manners," the idea is to get the food to your mouth in the most pleasant, natural, comfortable, and expedient way. This code does not place a premium of cleanliness or neatness. It does, however, provide conventions for cleaning up during and after the meal.

LaGrange, GA

Savoring Less Than Pristine Rural Ambiences

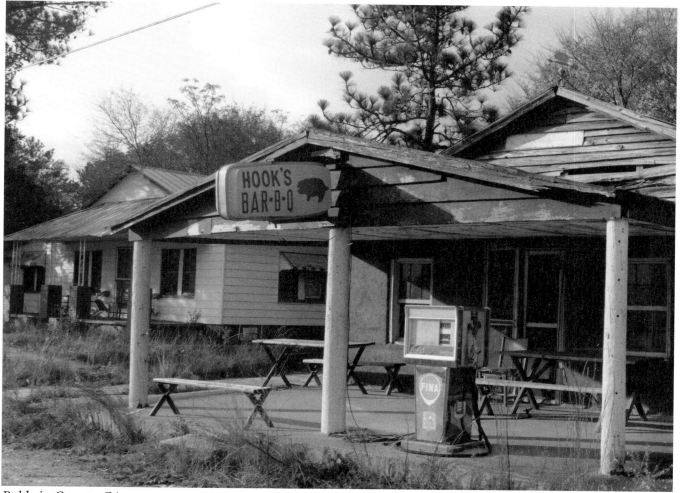

Baldwin County, GA

THE MYTH OF THE SOUTHERN BARBECUE JOINT

Today in the rural South old myths stubbornly linger. One of these insists that in order for a barbecue restaurant to be considered any good at all it must be "kind of seedy." In the North and in the Midwest, the term "barbecue joint" is often used, thus confirming that Southerners are not the only group clinging to the idea that good barbecue generally emanates from less than pristine environs. Now, "joint" is a word very much to the point, a word you can get your teeth into. Merriam-Webster defines a "joint" as "a shabby or disreputable place of entertainment." While the *American College Dictionary* is even more on the mark, defining "joint" as "a cheap sordid place as for opium or liquor." This is particularly meaningful when you look up "sordid," and find that the exact definition reads, "dirty or filthy, morally mean or ignoble." Now you may not presume to question the morals of barbecue and its purveyors, but that aside, this definition brings you very close to the idealized essence of a real Southern barbecue "joint."

Still, no matter how apropos, most Southerners never utter the phrase "barbecue joint." The term "joint" sounds kind of thirties-gangster-urban-Yankee to most true sons of the South. It thus tends to stick in their throats and is therefore little used in the region. Nor has the term "barbecue restaurant," passed many lips in Dixie. In the twisted tangles of the Southern mind, the phrase "barbecue restaurant" represents a kind of contradiction in terms. According to the myth, good barbecue can't come from a "restaurant," for the term itself implies far too much sophistication and urbanity. Besides it sounds suspiciously French, and that just won't do at all. Southerners generally refer to an establishment where they go to buy and eat barbecue as simply "a barbecue" or sometimes "a barbecue place," but rarely "a barbecue restaurant" and almost never a "barbecue joint." Whatever the name, as you have already noted, the place must be "kind of seedy."

THE BARBECUE SPEAKEASY

Actually in this context, Southerners don't really mean "kind of seedy" at all. They mean "*really* seedy." In fact, "seedy" may not be a strong enough word. Or perhaps it just does not convey quite enough information to sustain the full-blown myth. The complete myth insists that for Real Dixie Barbecue to be considered top notch, the place where it is made and sold must border on "downright despicable" in several ways. Perhaps you will suggest "grubby" and "decadent" and "sordid" and just a little "sinful," even a bit "dangerous." Whatever terms you choose to use to satisfy the myth, they must imply low standards of cleanliness, manners, and decorum, as well as a certain loose code of ethics. All of this taken together combines to create a rather shady impression. It is as if barbecue was long ago declared illegal by the federal government but is still available everywhere in Dixie thanks to a clandestine network of shadowy, redneck, "barbecue speakeasies." Thus, at least mythically in the Southern mind, the underground pur-

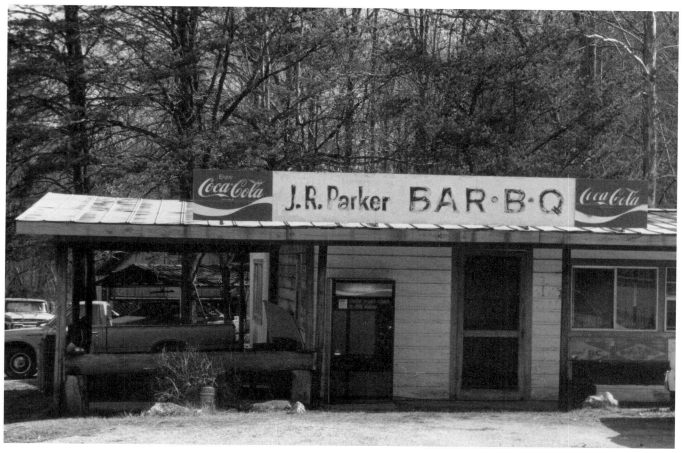

Homer, GA

veyors of so many delicious, sinful, seemingly illicit, smoky, porcine delights might be lumped together in the category with local moonshiners and the rumrunners of the Prohibition era. And so they often are in many areas. Many barbecue operators in Dixie still firmly cling to the myth, and they go to great ends to make sure that their establishments conform in every way to the very lowest standards of decor, hygiene, and amenity.

Many examples of this kind of cultivated, controlled squalor are to be found in the photographs and text of this book. Remember that you began your culinary quest on the dirt floor of Howard Thaxton's leaky, tin-roofed shed in Taliaferro County, Georgia, among dusty utensils, pots, and containers that probably date back to the Ark. But rural, Southern, barbecue take-out joints have no corner on the market when it comes to "seedy"

ambience. There are urban examples as well. Take for example the case of the Red Pig Barbecue in Concord, North Carolina.

THE RED PIG

Now Concord may seem a small town to some, but for most Southerners it will appear to be a pretty good-sized textile mill town with a reasonably large grid of downtown streets, a handful of traffic lights, regular paved sidewalks with street lights that all work, parking meters, fire hydrants, and, gosh, everything! There are even buildings over two stories high.

Years ago before it was cleaned up, remodeled, and expanded, the old Red Pig was a tiny store-front-diner-dive kind of place. You found it back up an insignificant side street. It catered primarily to a brisk take-out business, but the combination entry room, kitchen, dining room, and smokehouse also featured a short eating counter with a few low stools. The single room was always crowded, smoky, and dark, the floor awash with grit and beer. Pale walls loomed unadorned, held together by an ancient, smoked-on coating of brownish-gray grease. The only decoration was a small frame containing the mandatory North Carolina State Health Inspection Certificate.

Back in those days every establishment that served food to the public in North Carolina was required to have a health inspection periodically, and all were required to publicly display a certificate detailing the results. All across the state these certificates boldly flaunted each establishment's health rating like a classroom grade. They were everywhere. And virtually all of them, from Great Smoky Mountains to the Outer Banks, were stamped with a large blue "A." Now, if you traveled extensively in North Carolina, you would have noticed that even the meanest, shabbiest, foulest little roadside greasy spoon proudly displayed a great blue "A." You probably never saw a "B." But at the old Red Pig in Concord, they defiantly and perhaps triumphantly displayed a huge blue "C." And at the corner stool, just beneath that great blue "C" you could regularly enjoy some of the best barbecue ever created on this planet.

EXPLAINING THE ORIGINS OF THE MYTH OF THE BARBECUE JOINT

Although the myth of the seedy barbecue joint makes perfect sense to Southerners, you might be inclined to wonder, "How can a culture embrace and perpetuate a myth that suggests that in order to serve the very best food, a serving establishment must endeavor to debase itself in a series of degradations that include, but are not limited to, questionable standards of hygiene and cleanliness, poor ventilation, outrageously humble decor, rickety tables, slow service, muddy parking lots, myopically limited menus, and a generally bad attitude? Why not just make everything as clean and as accommodating and as pleasant as possible and still serve the same great food? Wouldn't that be better? Wouldn't your business then thrive?"

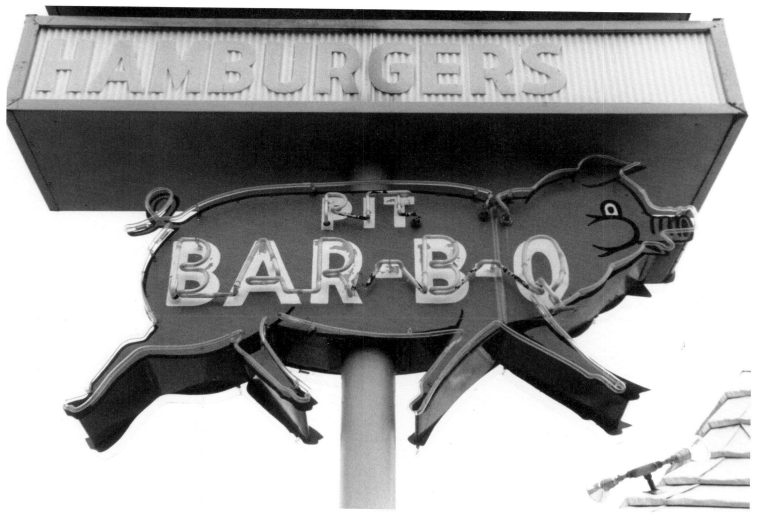

Concord, NC

For Southerners, the answer is definitely, "No! It would not be better! Everything, including the 'bah-bah-cue,' would not be as good. You people obviously don't know nothin' 'bout no 'bah-bah-cue,' anyway?"

There are several explanations for this attitude.

THE FIRST EXPLANATION

The first explanation is the most difficult because it is a thing of the gut, or "visceral" as some "Up-East Yankees" might choose to say. It is certainly something handed down from father to son, and probably something actually genetically inherited.

Few people today realize that when the twentieth century began in America, more than fifty percent of the population lived in rural areas and farmed, or at least worked in support of farming. In the South this number was more like eighty-five percent. Thus today, Americans, and Southerners most particularly, are almost all the grandchildren of true children of the soil and of the frontier. That's part of what makes them so stubborn and so contrary. This is not a thing that a few generations of city life can erase. In fact, a few generations of city life might have proved so stifling for many as to awaken a deeply cherished respect for the soil and a subconscious yearning for the frontier.

This is especially true of Southerners for several reasons. First, most Southerners don't have to go back in the family very many generations to find a farmer. Second, farmers in the Deep South were generally locked in a cycle of tenancy, poverty, illiteracy, and want from the end of the Civil War until well after the Great Depression. This cycle involved small farms with a few cash crops like cotton or tobacco. The rest was subsistence farming: corn, vegetables, a milk cow, and a few hogs. To this day the slaughter of a hog in many rural areas of the South is considered an almost sacred affair. The open fire was a part of life, and the smokehouse was every bit as essential to survival as today's refrigerator. Third, and perhaps most importantly, Southerners often tend to set themselves apart from the rest of the nation owing to a lingering frontier individualism, a stubborn unreconstructed rebel spirit, and a deep-seated dislike for authority of any kind, especially governmental authority. All of this has stewed together to create a portion of Southern society that still lives, at least spiritually, very close to the land. So a little dirt or sawdust on the floor or between your toes might create an environment where muddy boots do not have to be left at the door, where the open fire is not just inviting but a soothing distant memory, where everything smells and tastes of the land and awakens ancient and inborn instincts.

Now at this point many of you may complain, "Too poetic," or "All of this is just sappy 'moonlight and magnolias' born of a jejune romantic reverie," or "Way too much Faulkner." But have you not found shucked oysters or the clam chowder to be much better at the shabbiest little shack on the beach? You know, the one with oyster shells on the sandy floor. Don't those broken, musty shells under foot bring you just a little closer to the sea?

This gut feeling about the serving of certain

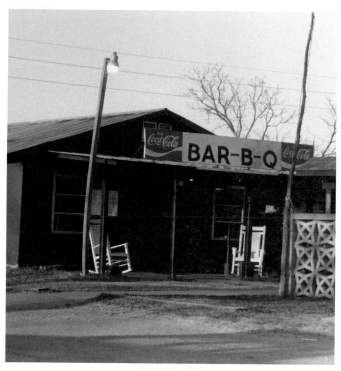

Winder, GA

only must a barbecue place be physically shabby, it must also convey a certain sense of risk and danger. The image of the "barbecue speakeasy" is apt here. If a place conforms correctly to the myth, patrons will inhale not only the smoky scent of a bucolic country ambience but also the subtle aroma of sin. In the best places these odors will combine to suggest that barbecue itself is some kind of contraband, consumed in secret and purveyed by shady characters operating just beyond the law.

Come on. Admit it. The pleasures of sin are well known to you: those glorious cigarettes secretly smoked out behind the gym when you were in high school, that first intoxicating sip of beer bought for you by the old wino when you were fifteen, *fois gras,* the fifty-dollar bottle of champagne that you couldn't afford. Remember! Those little bits of the turkey purloined while Dad was still carving were a great deal better than the perfect thin white slices he later put on your plate at the table. Just a little sin is exciting, exhilarating, erotic, and even appetizing. As for too much sin, well, that is beyond the scope if this book.

Certainly barbecue is off to a good start when it comes to sin. Everyone knows that barbecue does not exactly appear at the top of the American Heart Association's list of approved foods. In fact, the entire barbecue experience, if properly enjoyed, is all about excess: too much meat, too much fat, and extremely poor dietary balance. There is a barbecue place in rural Mississippi that maintains a large sign over the entrance that reads, "WARNING! You are

foods in authentic or rustic environments is not just a Southern thing, although in the case of barbecue, Southerners may feel it more acutely. The feeling is inborn in everyone, for at its heart it goes all the way back to the days when your distant ancestors far across the sea used to build great fires, roast wild game, paint themselves blue and howl at the moon. In short, it goes all the way back to Prometheus.

THE SECOND EXPLANATION

The second explanation involves human nature. There is a part of the myth that tells you that not

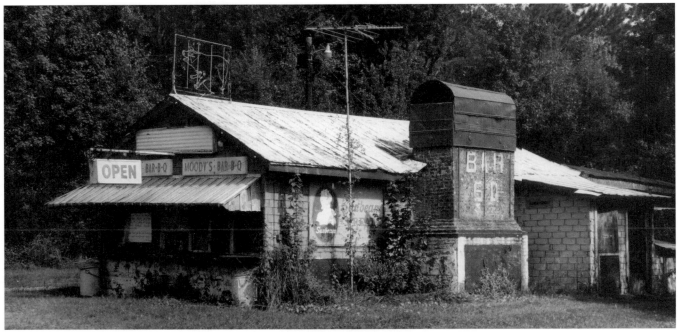

Kingsland, GA

about to enter a SALAD-FREE ZONE." If you couple this kind of sinful excess with a shabby and sufficiently dangerous and shady Southern barbecue ambience, then a certain titillation of the spirit (and of the appetite) takes place. No wonder the food tastes better.

THE THIRD EXPLANATION

The third explanation is easier, for it is contemporary, something you can sink your teeth into. It involves the fact that in most rural areas of the South, maintaining the appearance of a certain lack of *savoir-faire* is desirable. Indeed, to appear too up-to-date, too urbane, too slick is not stylish. Most like to walk a kind of redneck, NASCAR walk and talk a kind of hayseed, Hank Williams talk. Driving an old, beat-up pickup truck is more a badge of honor than an indication of poverty. Bib overalls are often the mainstay of the dress code for rich and poor alike. In many rural areas "shabby-rustic" is a way of life, while "citified sophisticated" is spurned. In this context, the myth of the seedy "barbecue joint" makes perfect sense. Shoot, I reckon!

But don't be fooled. Few of the characters presented in this book are ignorant, and none are stupid. Also think twice if these pages appear to

patronize. Often in their efforts to appear down-home, many rural Southerners will fake ignorance, hiding what they know. Thus, it often becomes a question of who is patronizing whom.

THE FOURTH EXPLANATION

The fourth explanation is the simplest of all. It involves tradition. Southerners are married to their traditions. In a region where people are slow to welcome change of any kind, traditions are sacrosanct. If a notion has been around long enough to become a tradition, then every man, woman, and child bold enough to call himself or herself a Southerner will defend and perpetuate it without question, no matter how impossibly archaic it has become. So if tradition holds that a barbecue place should be "kind of seedy" in order for the meat to be just right, then "seedy" it will be. To hell with modern trends and the strict new county health codes. All of the old copies of *Better Homes and Gardens* collected by all of the Martha Stewarts in the world will never change this. It's a tradition. It's the way it has always been, and it's the way it always will be. World without end. Forever and ever. Amen.

THE FUNK FACTOR

The funk factor is the name given to a system for rating exactly how well a barbecue place conforms to the myth of the seedy "joint." It is a simple scale of one to ten, which can be used to rank any establishment. The higher the score, the worse the place, which is to say the better.

Take for example the floor covering. What material would get the highest funk factor? Well, dirt of course, followed closely by dirt covered with sawdust, and then dirt covered with gravel. So dirt would get a funk factor of 10, while sawdust or gravel might rate a 9. Farther down the list you will find loosely fitted, weathered, wooden boards with no sub-floor. This might get an 8, while a raw concrete slab might rate a 7. Linoleum or other types of synthetic tile flooring might rate anywhere from 6 to 4 depending on the age and condition. If there are a number of missing tiles revealing large areas of the black mastic used to glue the tile down, then a 6 or even a 7 would definitely be in order. Finished wood floors would rank a bit lower, say, 3 to 5 depending of the quality, age, and condition. At the bottom of the list would be new ceramic tile, and last of course would be carpet, which would generally get a 1 or even a 0 if it were really nice.

Simple, eh? Well, not so fast. Remember, you are talking about the South. Down here nothing is simple because everything must undergo enough traditional scrutiny to create those maddening contradictions and labyrinthine exceptions that only true Southerners can begin to unravel.

THE FUNK FACTOR REVISITED

If the examples given above tend to suggest that the key to the funk factor is something rustic, weathered, and well-worn, well then, maybe so. But this is not always the case. Remember, you noted that many of the old "authentic" barbecue "joints" have recently become the victims of hapless remodel-

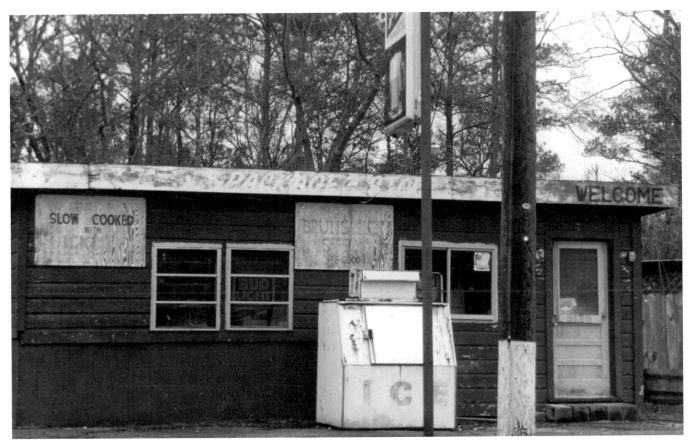

Rome, GA

ings. Some are pretty darned nice, thus robbing many refurbished establishments of their former high funk factor ratings. But other remodelings are pretty darned cheap, and here you encounter new, subtler, more modern, more insidious criteria for very high funk factor ratings that have nothing to do with "weathered and well-worn." This is to say that if the remodeling is cheap and sleazy enough, you might be forced to modify the rating rules a bit in order to award higher funk factor marks for, say, a really low quality acoustic tile ceiling, no matter how new, or for really cruddy aluminum or plastic widows. (Plastic alone in sufficient abundance can lead to very high marks.)

What is more, some of the new breed of Dixie Barbecue pretenders have purchased or leased buildings that were originally intended for another use. Without a proper remodeling, such an architectural mismatch is certainly worth a few points in most funk factor rating schemes. Some of these are quite

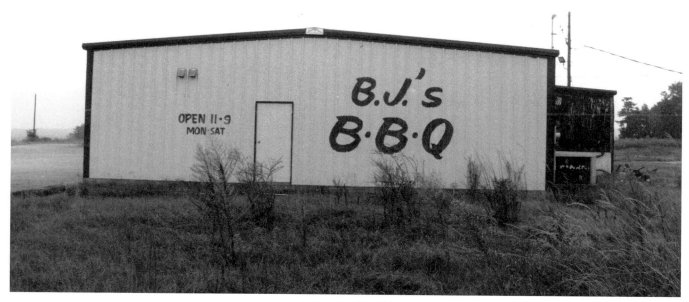

Moundsville. AL

nice and thus are of little interest to you here. But some represent pretty wild and singularly tasteless adaptations. (Like plastic, tastelessness stands in very high esteem when it comes to determining the funk factor.)

In addition to all of this, many new barbecue purveyors in Dixie have built their own brand-new buildings. Again some are very nice and thus don't concern you here. But some are Spartan to the bone and deserve special consideration. Many of these are nothing more than cinder block shells or metal structures of even lower quality. Some even employ mobile homes. Take one of these metal buildings, erect it on a concrete slab or just on well-packed earth, and then set up your pit or cooker. Add no ventilation, no interior walls, no decor of any kind save a few chairs, tables, and a Formica counter, and you have an establishment that might rate as high as an 8 on a well considered funk factor scale, despite the fact the building and everything in it is brand spanking new.

QUANTIFYING THE UNQUANTIFIABLE

With all of this in mind, you can now construct little charts like the ones that follow to help determine the funk factor of the various constituent parts of any barbecue establishment. This approach might be applied to floors, ceiling treatments, interior walls, window treatments, and of course the overall construction type of the building itself.

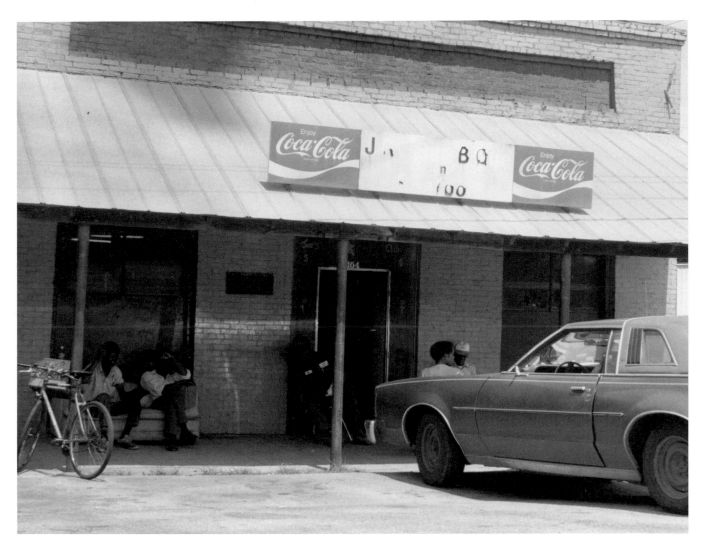

Leesburg, GA

From here with a little subjective adjustment, statistical weighting, and various other intuitive and/or mathematical manipulations like the ones suggested in the "Add-ons and Deductions" guide that follows the empirical rating charts, you can calculate an overall funk factor for any place.

Given the guidelines below, an overall funk factor of 6 or above denotes an environment of sufficient shabbiness to allow for the creation of really good Dixie barbecue. But remember, these are just guidelines. For example you might rank a carpet floor quite a bit higher if it were really filthy, badly stained, burned, mildewed, or coming unglued at the edges.

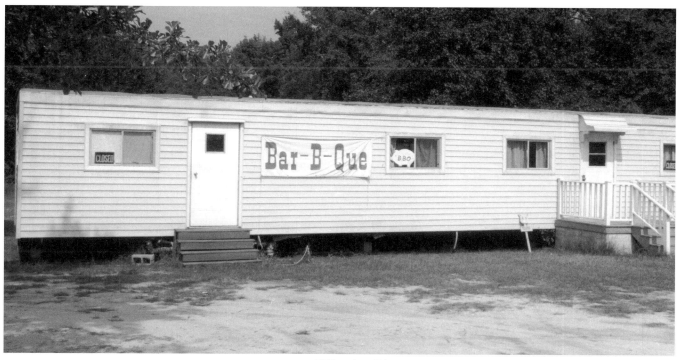

Hiltonia, GA

A Funk Factor Rating Guide

Use only one choice per chart. If the exact description is not one of the choices you must interpolate. In cases of either extreme shabbiness or high quality workmanship, creative extrapolation is encouraged. Multiply each rating by the corresponding "Weight." Then add the results and divide the result by 6. Adjust using the "Add-ons and Deductions" on the next page. Finally you may choose to use the rater's discretionary adjustment of up to +/- 1 full point if you feel that the calculated rating does not accurately reflect the true "funkiness" of the establishment, or if you find noteworthy elements not mentioned in the "Add-ons and Deductions." For example a framed likeness of John Wayne is certainly be worth at least a quarter point.

Building Types - Weight+2	
Open wooden slats	10
Corrugated metal panels	9
Plywood or fiberboard siding	8
Wood covered with roofing	7
Log	6
Unpainted batten or clapboard	5
Cinder block	4
Prefabricated metal	3
Painted wood	2
Brick, glass or tile	1

Flooring - Weight = 1	
Dirt	10
Sawdust or gravel over dirt	9
Rough wooden planks	8
Concrete slab	7
Aging inoleum or synthetic	6
Newer linoleum or synthetic	5
Other aging tile	4
Finished wood flooring	3
New ceramic tile	2
Carpet	1

Interior Walls - Weight = 1	
Exterior wood exposed	10
Corrugated metal, exposed	9
Unpainted cinder block	8
Plywood or fiberboard panels	7
Painted cinder block	6
Unfinished wood paneling	5
Fake wood paneling	4
Finished wood paneling	3
Sheetrock	2
New ceramic tile	1

Window Treatment – Weight = 1	
No windows	10
Open windows, no closures	9
Plastic sheeting	8
Wooden shutters	7
Screen	6
Plexiglas or plastic	5
Glass, aluminum frame	4
Glass, wood frame, casement	3
Glass, wood frame, sashed	2
Plate glass	1

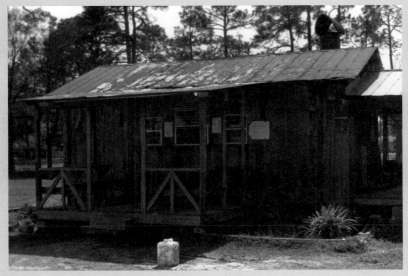

Homerville, GA

Ceiling - Weight = 1	
Exposed metal roofing	10
Exposed wood roof decking	9
Exposed vents or pipes	8
Fabric or net hangings	7
Rough wood paneling	6
Fake wood paneling	5
Finished wood paneling	4
Acoustic tile glued to ceiling	3
Sheetrock	2
Drop ceiling w/ acoustic tile	1

Funk Factor Add-ons and Deductions

NEIGHBORHOOD

- If the establishment is outside of the official town limit, add a half point; or if the establishment is on a dirt or a gravel road or if there are no other structures within one mile of the establishment, add one full point.
- If the establishment is within a half mile of any modern fast food restaurant or any multistory office building or any strip mall, deduct a half point.

PARKING

- If the establishment's parking lot is either dirt or gravel, add a half point.
- If the establishment's parking lot is paved but contains potholes large enough to cause serious tire damage, you may also add a half point.
- If there are painted lines to designate parking spaces in a lighted paved parking lot, deduct a quarter point; or if there are designated handicapped parking spaces, deduct a half point.

SERVICE

- If the establishment offers table service with waiters or waitresses, deduct a quarter point. But if there are waiters and/or waitress and any of them (or any other staff member) at any time addresses you or anyone in your party as "Sweetie," "Honey," "Darlin'" or "Sugar," add a half point. Likewise if a staff member calls you "Buddy" or "Son," or, if you are a female or a child and any staff member addresses you as "Sunshine," "Pun'kin" or "Little Darlin,'" you may add a half point; or if anyone on staff addresses you as "Good Buddy" or "Ol' Buddy," you may add one full point.
- If anyone on the staff suggests that you should, "Have a nice day," deduct two points and leave.
- On the other hand, if anyone on the staff invites back you by saying, "Y'all come back, now," you may add a half point; or if it's "Y'all come back now, ya heah?" add one full point.
- Waitresses in T-shirts are worth a quarter-point addition, although this is not true of waiters.
- If you are served on china (or any reasonably rigid platelike facsimile) with real stainless steel utensils deduct a quarter point. You should deduct an additional half point for any use of cloth napkins.

- If you are served "regular ol' American sliced white bread," add a half point. If it is served on the table in the original wrapper, add another half point; or if the packaged bread on the table is either "Sunbeam" or "Colonial" brand, add one full point.
- If there are printed menus presented at the table, deduct a half point. Take-out menus or counter menus do not constitute a deduction.

DECOR

- Any display of the Confederate Battle Flag or "Forget, Hell!" or "Save Your Confederate Money, Boys" posters or signs or any likeness of R. E. Lee, Jeb Stuart, or Stonewall Jackson adds a half point; or if you encounter a likenesses of Jefferson Davis or Alexander H. Stephens, add one full point.
- Plastic flowers add a quarter point, as do any combination of the following decorations: NASCAR paraphernalia, displays of firearms, pictures of Jesus, mounted deer or wild boar trophies, or stuffed largemouth bass. Other types of taxidermy do not constitute an addition.

OTHER

- If the establishment is in a house trailer (mobile home), add two points.
- If there is a hand-painted outdoor sign, add a half point, but only if it is not professionally done and if there is no other outdoor signage. For each backlit plastic outdoor sign, deduct a quarter point, up to three-quarter points.
- If there are no restrooms or if you have to go outside to get to the restroom, you may add one full point.
- If among your fellow diners you find an armed, obese, uniformed, law enforcement official, you may add a half point. (Extremely overweight security guards do qualify, but only if heavily armed. Groups do not constitute multiple deductions.)
- If the number of pickup trucks in the parking lot is greater than six and if that number outnumbers conventional vehicles in the parking lot by at least three to one, then you may add a half point.
- If a working pit or cooker is in front of the establishment, add a half point.
- If the establishment has a web site, deduct one full point.

DIXIE BARBECUE VS. PUBLIC HEALTH

After a brief study of Southern barbecue "joints" and their inherent "funkiness," you may be ready to abandon your search for the Dixie Barbecue for fear of food poisoning, or worse. Stand fast. Do not forsake your quest. You may get sick at that little oyster shack at the beach, and you may occasionally even get sick at Sardi's. But you will not get sick at the Real Dixie Barbecue. All Southerners know this. Here is how they know.

First, everyone knows that all bacteriological activity stops at a temperature between 160 and 170 degrees Fahrenheit. And every Southerner knows that barbecue is cooked for 10 to 24 hours at temperatures around 200 degrees or so. Add to this the fact that the meat is usually generously salted and, while it is cooking, it is also smoking for all of these hours. Now, everyone knows that cooking, salting, and smoking are the oldest, surest meat-preserving techniques known to our species. *Ergo,* Southerners know that, although their barbecue might sometimes contain a little grit or ash, it is always clinically sterile when it comes from the pit. They also know that during and after the cooking most Southern barbecue is liberally sauced with a mixture containing, among other things, large amounts of vinegar, salt, and red and back pepper, the perennial uncontested heavyweights of food preservation worldwide. Thus, Southerners know that real Dixie barbecue is highly unlikely to spoil, no matter what.

After a few weeks it might get really dry or even a little moldy, but it won't spoil.

So what else is there for you to worry about? The baked beans are bubbling away on the back burner. The coleslaw is marinated in a germ-exterminating brew of salt and vinegar. Then there's the potato salad. Well, maybe this could be a problem. Still, three out of four ain't bad, and if you're really worried about the potato salad, well, you can just skip it altogether. Then again, you are in Dixie. Hell, take a little chance. Live on the edge for a change. Do like the Southerners do and break a rule every so often. It is very freeing. You'll see.

The potato salad notwithstanding, no matter how base the surroundings there is little to fear. All you're gonna get is barbecue, slaw, beans, and maybe a few slices of American White Bread right from a freshly opened package; maybe a bag of chips or some French fries hot from 375-degree oil. So what's the risk? If you are concerned about the sanitary standards of the plates and tableware, don't be. At the very best places you'll get paper plates, plastics forks, and reams of paper towels.

I promise, you won't get sick after a meal at the Real Dixie Barbecue. But until you learn to savor the funky rural ambience along with your food, you might feel a little queasy when you first walk in.

The Difference between Black Barbecue and White Barbecue

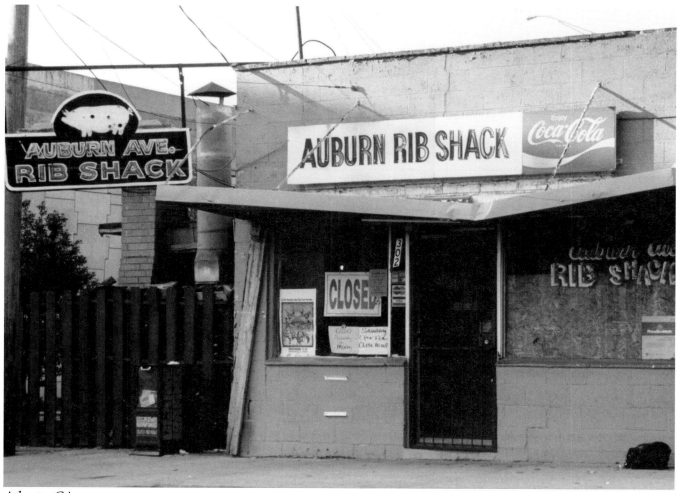

Atlanta, GA

Barbecue and Race

Today in the rural South, ancient myths stubbornly linger. One of these insists that there is a difference between black barbecue and white barbecue. In light of this widely held but little discussed opinion and since you are searching for the Dixie Barbecue anyway, you might set out to unearth all of the divergent ethnic Southern barbecue traditions you can find. But in the end the rocky ground surrounding this purely gastronomic inquiry will probably prove difficult to traverse, because you will constantly find yourself stumbling into the well-concealed pitfalls of race.

Now race is a tricky subject, not just in the South but everywhere on the planet. But race is not the subject you wish to explore. You want to know about barbecue. Unfortunately the secrets of barbecue are not always any more forthcoming than the secrets of race. But, thank heaven, the language of barbecue is much lighter and more open than the shrouded, smoldering vocabulary of race. It is thus the lighthearted, offhand vernacular language of Southern barbecue that you must use. And if then your approach to race seems to others to be flip, cynical, politically incorrect, or in any other way out of line, you must constantly remind them you just want to talk about barbecue.

Probing Near the Nerve

Well then, is there really a difference between white barbecue and black barbecue? All of your extensive personal "taste test" samplings in various regions of the Deep South will eventually prove inconclusive. So after all of that, you might decide to discuss the matter with a number of "barbecue experts," both black and white. And soon you will began to speculate that, like so many ethnic "differences," distinct, separate, ethnic, Southern barbecue styles might be more a matter of ingrained perception than a matter of fact. Nonetheless, you plod on, and if you are persistent you will finally figure it out. In the end, the discovery of the subtle difference between white barbecue and black barbecue, whether real or perceived, probes very near the tender nerve of what it means to be Southern.

Metaphors for the Truth

You might begin by asking a seasoned African-American Southern pit boss what he thinks. In response, you'll probably get an answer something like the one that follows. These are the words of a handsome seventy-year-old black man down in Elmore, Alabama, who claims to have begun his professional barbecue career at the age of twelve. "Well, you know if you cook it at all, then all barbecue is white. The pork meat is white when it is cooked, and it is the flavor of the pork that we want. When we want the flavor of chicken, well then, we eat chicken. But if we want the flavor of the pork, we cook pork, and the pork is white when it is cooked. Now, mind you I can make it black. I can make it as black as you might want. But then that's no good. And if it is too white, then that ain't no good either. The truth is, it is when it is a nice

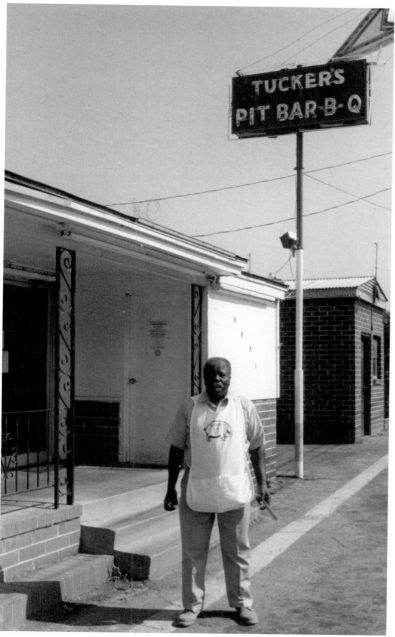

Macon, GA

brown color that it is the best. I mean, the sauce is brown and the outside is brown and crusty, maybe with a little black, and the inside is brown, maybe with a little juicy white, and that's when everything is just right." He might go on like this for several minutes.

You will later find that conversations with white Southern barbecue experts will yield equally mystifying responses. After you have given the matter a lot of thought, you may conclude that there are three possible explanations for these incomprehensible diatribes. There is a possibility that they are so naïve or so focused that they do not understand your question and think that you have asked just another barbecue question. There is the more likely scenario that they understand your question perfectly but do not want to go there, so they just ramble and "blow smoke," eluding you and even possibly poking fun at you. And then there is the remote chance that they give you a metaphor for the truth: that there is no difference between black barbecue and white barbecue, there is only good barbecue and not so good barbecue; and that good barbecue exhibits some kind of harmony between black and white traditions.

MYTHS, MONIKERS, AND LEGENDS

Whatever the case, you'll find that most people take an evasive tack. Sometimes these evasions become quite complex. Take for example the case of Bubba's Barbecue, a tiny place you'll find in northwestern Georgia. It is just a little shack of a place beside the road with a big metal cooker out front. If you walk up to the window, ask for a barbecue sandwich, and strike up a conversation with the young black man who takes your order, after a few minutes you may realize that you are talking to the owner. So you might ask jokingly, "Are you Bubba?"

He laughs and says that indeed he is not.

"Then who is Bubba?"

"Well," he replies, "I guess you could say that it's just a social moniker."

Despite the obvious sophistication of this answer, you know that this situation is not unusual. Black-run barbecue joints catering to largely white clienteles are commonplace in the South. In fact, today many joints reflect no color at all. This is to say they recognize no ethnic differences in cooking techniques and no distinction in the clientele to whom they cater. Everyone is welcome. Add to this the fact that if you visit the pit house at many, if not most, "white" barbecue joints in the Deep South today, you will find a black pit boss or cook to further blur whatever lines of ethnic distinction that may or may have once existed.

Rome, GA

Elmore, AL

CONSENSUS

Not everyone is evasive. Some are bold enough to offer hints of an opinion. But most of these are based on narrow, anecdotal, personal experiences. No one seems to have attempted any broad sampling. In the end, when taken all together, these opinions constitute little more than a tangle of contradiction. Some white folks say they think that black barbecue sauce is too sweet. While others think it is too bland. Some say black barbecue is over-cooked, too dry, and too crispy. Some say it is too fatty, thus implying that it is undercooked and too moist. Likewise some black folks seem to think that white barbecue is not spicy enough, while others say whites generally use too much red pepper for their tastes. It goes on and on. In the end, no firm consensus emerges. Still, despite the fact that most people are unable to specify what the difference is, almost everyone agrees that there definitely is a difference between black barbecue and white barbecue.

THE REAL DIFFERENCE

If you look closely enough, you might eventually glean the truth. The real difference between black barbecue and white barbecue is not about sauce and smoke and cooking technique. In fact, it's not really about barbecue at all. It never was. It is about all the sweaty, earthy fears and blind human perceptions that sustain real myths and legends. To

Atlanta, GA

discover the real difference between black barbecue and white barbecue, you'll have to go back to 1959, back to the summer you were fifteen and sit in the back seat of a '57 Chevy on the outskirts of town with three older white boys, waiting for a still older, fat, blue-eyed schoolmate who has just disappeared into a dark, dilapidated rib shack. Waiting in an unlit parking lot surrounded by the looming, smoke-shrouded figures of strange black men who are drinking beer and talking in low tones and listening to soft, jazzy, intoxicating music. Waiting, about to pee your pants, for the fear that one of them will come over to the window of the car and ask, "What the hell you boys doin' heah?" And then out comes your friend with brown paper bags filled with ribs and two six packs of cold Pabst Blue Ribbon beer, and he revs the engine, and the next thing you know you are beside the cool, green river, and you are passing around the now grease-spotted brown bags and handing out ribs and paper napkins and cans of beer and little paper cups filled with extra sauce, and you bite into the ribs and take a big sip of cold beer, and it's the best barbecue you have ever tasted. And in that instant, when the beer goes straight to your head, there is a difference between black barbecue and white barbecue, and you light up a Lucky Strike, and you sit back and inhale deeply and stare at the glowing ash for a long time, and you think, "It wasn't the delicious smoky ribs we were really after. It was the fire."

Bragging Rights and Other Regional Exaggerations

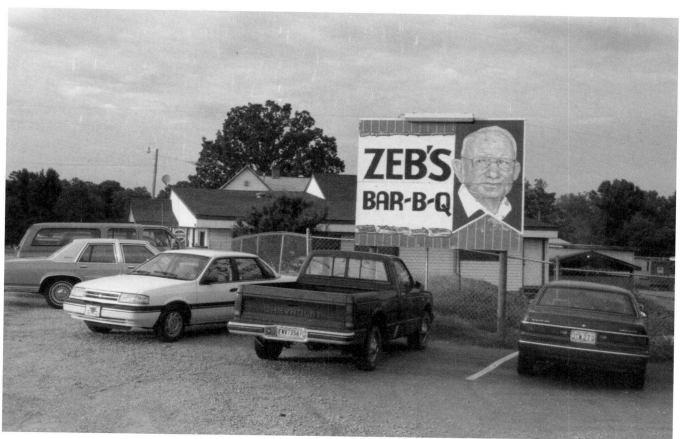

Danielsville, GA

WHY SOUTHERN LIES ARE NOT REALLY LIES AT ALL

While you are out there searching for the Dixie Barbecue, you will undoubtedly discover tangles of Southern contradictions. One of these is manifest in various declarations that appear on the hand-painted signs that decorate many roadside barbecue joints in Dixie. From Natchez to Norfolk, barbecue purveyors blatantly publish outrageous claims on signs of all sizes and shapes: "Best Barbecue in Calhoun County" or "Best Barbecue in Alabama" or "Best Barbecue in the World." Now, how can one guy have the "Best Barbecue in Alabama," if just down the road, his competitor claims the "Best Barbecue in the World" or in "the Galaxy" for that matter? The usual laws of logic do not allow for such collisions of sets and subsets. But remember, you are in the South where all laws of man and of nature are bent into mysterious knots of contradiction. In the Southern mind these claims are totally reconcilable. Here is why.

Southerners love a tall tale. They revel in impossible exaggerations and shameless braggadocio. This is the stuff of the American frontier, the stuff legends are made of: fabricated heroes like Paul Bunyan and Pecos Bill, and larger than life real characters like Daniel Boone and even ol' Andy Jackson himself. Davy Crockett killed his first bear at the age of three, and Ol' D. Boone "kilt his bar" on that tree in 1830 with his bare hands. Probably strangled the hapless critter. Or so they say. Sure, and Fireball Roberts learned to drive as a little kid running moonshine in the mountains of North Carolina. And Ty Cobb, well, Ty Cobb, now there's a Southern story for sure. Just ask anyone.

But it must be remembered that all of this folly is allowed only within the bounds of a very specific and strict Southern code of ethics. This is to say that in the South there are certain things that one never exaggerates or brags or lies about; and there are certain other things that one is expected to exaggerate, brag, and lie about. Unfortunately you have to be a Southerner to know which things are which. For example, Southerners almost never exaggerate or lie about personal exploits or accomplishments. They rarely tell war stories or embellish their achievements of the playing fields of youth. However almost never is not never, and when it comes to hunting and fishing, the sky is limit. The big one that got away must have gone at least twenty pounds, and the mouth on that thing: "Well, I could have put my whole damned arm down his throat." Or the big buck with the rack so high that it was lost in the clouds. Or whatever. By now you may be beginning to suspect that barbecue is one of those subjects usually considered fair game for exaggeration, one of those subjects that begs for a good creative lie. And so it is. But for Southerners, this is not really lying. How can it be a lie if everyone knows it's a lie? How can it be a lie if no one is fooled?

LARGER-THAN-LIFE BARBECUE

The simplest form of barbecue bragging involves making things larger than life. This can be accom-

plished in a number of ways. The most common is to display impossibly large signage. But outrageous effects can also be achieved by bizarre decorations that carry the funk factor beyond the usual limits. Wild displays of tasteless folk art or piles of colorful junk and memorabilia can create exaggerations unlike any on a printed sign.

FAMOUS BARBECUE

Another popular way to exaggerate the merits of any barbecue joint is to declare it "famous." All across the South signs declare, "Heavy's Famous Big River BBQ" or "Big John's Famous Brunswick Stew" or "Jake's Famous Low County Bar-B-Q." Such claims are probably fair enough, for they fail to communicate the constituency with whom these products are so well known. Perhaps Big John's stew is legendary all across the South, or perhaps it is just pretty familiar to most folks in the eastern half of Escambia County, Alabama.

The phrase "World Famous" is equally suspect. Perhaps an English family happened to eat in a certain barbecue joint while on vacation in Mississippi, and perhaps they liked the food so much that they promised the waitress that they would tell all of their friends back in Liverpool how great the place was. Doesn't this, at least in one sense, make the place "World Famous?" Or maybe, kind of? No? Well then, hell, perhaps there was no English family at all, and the owner of the place just liked the sound of the words "World Famous." Who's to prove it is not?

Buttahachee, AL

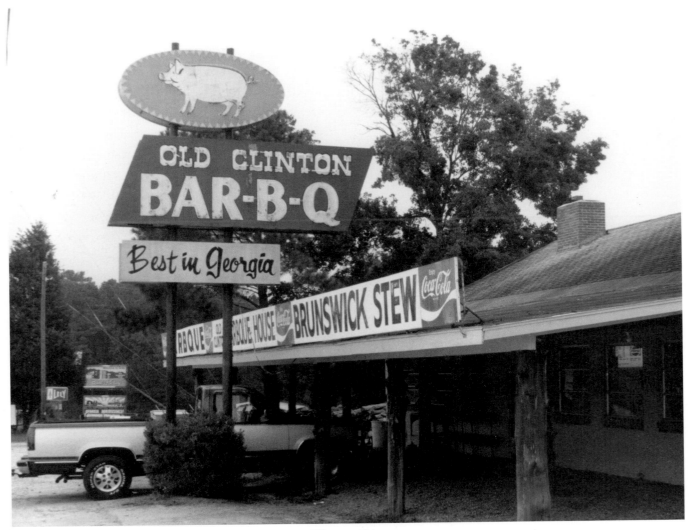

Clinton, GA

Fort Gordon, GA

BARBECUE SUPERLATIVES

Far and away the most common and the most blatant way to accomplish a really shameless barbecue exaggeration is to simply call the product of your art "The Best." What more is there to say? Here is an exaggeration that true Southerners can cherish and admire for the bold-faced lie that it is. If you search hard enough, you will find at least seven barbecue joints in Georgia claiming to serve "Georgia's Best Barbecue," and another two or three more claiming the "Best in the South," and yet a couple more who go all of the way and claim to be "The World's Best." The picture is the same in the Carolinas, Alabama, and Mississippi. If you dig in and ask some questions, you will find that some of these claims have a backing of sorts. One place will tell you that the father of the present pit boss won the title of "Best Barbecue in Georgia" at the state fair back in 1954 and that the same recipe is still used today. Another will say that the validity of his claim comes from a first-place prize at the "Mule Days Festival" in Tifton, Georgia, back in 1993. And so it goes.

But all of this is just blowing smoke. The truth of the matter is really simple. Remember, everyone who seriously pursues the slow cooking and saucing of pork shoulder in the Deep South fervently believes that his or her recipe, technique, pit or cooker, and sauce is "The Best." Other products may be get high praise like "Passable," "Not Too Bad" or "Not Half Rotten," but only your own can be "The Best." To real Southerners this does not seem prideful, boastful, or even self-centered. It is just an irrefutable fact. And thus if dozens of joints from Biloxi to Brunswick advertise "The Best Barbecue in the Known Universe," Southerners find little contradiction in such claims.

BRAGGING AT THE REAL DIXIE BARBECUE

As we noted, all of this is just blowing smoke. When you find the Real Dixie Barbecue, if you ever do, you'll probably find the sign to be modest. It will probably just read, "BBQ." That is, if they have a sign at all.

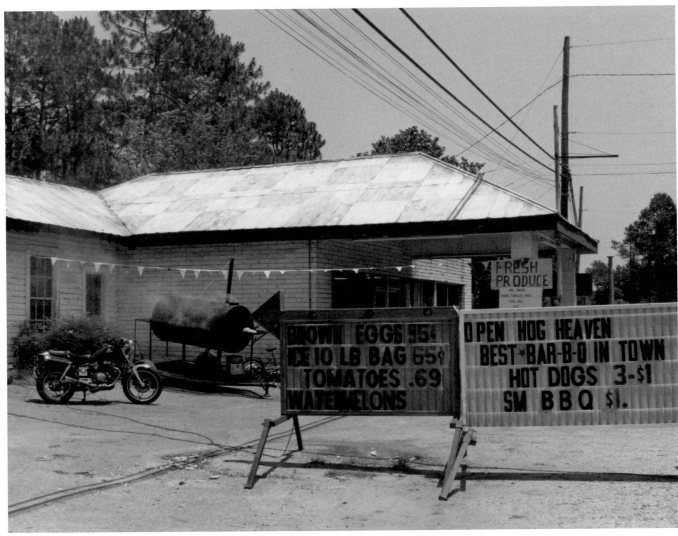

Americus, GA

Epilogue
Finding the Dixie Barbecue

Coal Mountain, GA

If you are persistent, if you do all your homework, make all the right inquiries, do all the driving, and if you are lucky, you may someday actually find the Real Dixie Barbecue. It's still out there somewhere, out in the piney woods, way off the beaten track. But it probably doesn't look the part anymore. It's probably no longer rustic or even quaint. Maybe it now has new metal siding and bare walls and a concrete floor. Maybe there are no windows and no funky rural Southern decorations: no plows, no flags, no pictures of Lee or Jackson or Jeff Davis or even George Wallace. Maybe the place is so remote, so nondescript or so seedy that you are just a little afraid when you dare to open the door and walk in.

But you know it when you find it. Despite the lack of ambience, the place somehow speaks to you in a way that cannot be expressed using a tool so imprecise as language.

Once inside, you walk up to the counter. A very large bearded man looks you over carefully, frowns darkly, and then, as if to begin some kind of interrogation he asks, "What-y'all havin'?"

"A barbecue plate," you reply.

"Here or to go?"

"Here."

"Pulled, chopped, or sliced?"

"Pulled."

"Inside or outside?'

"Inside."

"Hot or mild?"

"Hot."

"Slaw, pot-sal, or beans?"

"Slaw."

"What-cha drinkin'?"

"Bud Lite."

"Take a seat."

"Sure."

As you begin to walk away, he stops you. "Y'all not from 'round heah, are ya?"

"Nope," you reply.

You take a few steps, and then quickly look back at him, and you catch a glimpse of his smile for the very first time. Suddenly you know that you have just passed a very strict test that not everyone can pass.

Perhaps you have finally found the Real Dixie Barbecue. Or perhaps it has finally found you.

Calera, AL

Fort Davis, AL

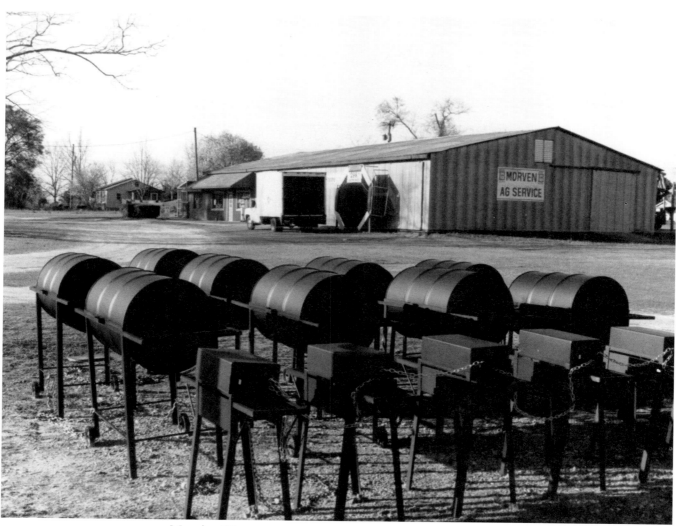

Morvin, GA

If you enjoyed reading this book, here are some other books from Pineapple Press on related topics. For a complete catalog, write to Pineapple Press, P.O. Box 3889, Sarasota, FL 34230 or call 1-800-PINEAPL (746-3275). Or visit our website at www.pineapplepress.com.

Bansemer's Book of Carolina and Georgia Lighthouses by Roger Bansemer. This volume accurately portrays how each lighthouse along the coasts of the Carolinas and Georgia looks today. (hb)

Bansemer's Book of the Southern Shores by Roger Bansemer. This artist's journal describes in words and images the colorful places nestled up and down these coasts. (hb)

Best Backroads of Florida by Douglas Waitley. Each volume offers well-planned day trips through some of Florida's least-known towns and little-traveled byways. Volume 1: The Heartland (pb); Volume 2: Coasts, Glades, and Groves (pb); Volume 3: Beaches and Hills (pb).

Classic Cracker by Ronald W. Haase. A study of Florida's wood-frame vernacular architecture that traces the historical development of the regional building style. (hb, pb)

Coastal North Carolina by Terrance Zepke. Gives the history and heritage of coastal communities, main sites and attractions, sports and outdoor activities, lore and traditions, and fun ways to test your knowledge. Over 50 photos. (pb)

Discovering the Civil War in Florida by Paul Taylor. This book covers the land and sea skirmishes that made Florida a battleground during the Civil War. (hb, pb)

Essential Catfish Cookbook by Janet Cope and Shannon Harper. Full of mouth-watering recipes that call for succulent catfish and a variety of easy-to-find ingredients. (pb)

Coastal South Carolina by Terrance Zepke shows readers historic sites, pieces of history, recreational activities, and traditions of the South Carolina coast. Includes recent and historical photos. (pb)

Gardening in the Coastal South by Marie Harrison. Discusses coastal gardening considerations and environmental issues. Color photos and pen-and-ink illustrations. (pb)

Guide to the Gardens of Florida by Lilly Pinkas. A comprehensive guide to Florida's gardens. Learn the history and unique offerings of each garden, what plants to see and the best time of year to see them. Traveling outside of Florida? Check out *Guide to the Gardens of Georgia* (pb) and *Guide to the Gardens of South Carolina* (pb) by the same author. (pb)

Lighthouses of the Carolinas by Terrance Zepke. The stories of the eighteen lighthouses on the coasts of North and South Carolina, with visiting information and photographs. Newly revised. (pb)

Southern Gardening: An Environmentally Sensitive Approach. by Marie Harrison. A comprehensive guide to beautiful, environmentally conscious yards and gardens.(pb)

Tales from a Florida Fish Camp by Jack Montrose. Reminiscences about the good old days fishing on the St. Johns River. (pb)

A Yankee in a Confederate Town by Calvin L. Robinson. The only account of the Civil War in Florida written by a resident who sided with the Union. (hb)